IMAGES
of America

FLORIDA'S HISTORIC
AFRICAN AMERICAN HOMES

IMAGES
of America

FLORIDA'S HISTORIC
AFRICAN AMERICAN HOMES

Jada Wright-Greene
Foreword by Althemese Barnes
Afterword by Vedet Coleman-Robinson

ARCADIA
PUBLISHING

Published by Arcadia Publishing
Charleston, South Carolina

Printed in the United States of America

Library of Congress Control Number: 2020951640

For all general information, please contact Arcadia Publishing:
Telephone 843-853-2070
Fax 843-853-0044
E-mail sales@arcadiapublishing.com
For customer service and orders:
Toll-Free 1-888-313-2665

Visit us on the Internet at www.arcadiapublishing.com

*To Diem, JR, and Dior, this book is the first of many
accomplishments I hope to leave as a legacy for you.
I dedicate it to you, my three priceless jewels.*

CONTENTS

FOREWORD

What is in a house? Beyond walls and wooden panels lie strong images that expose unyielding spirits of the children that lived there, the sheltering compassion of a mother and father, cloaks of shelter, warmth, and security. What is in a house? Underneath the tin roofs and above the concrete pillars are the spirit of community and the abode of scholars, entrepreneurs, activists, civic and religious leaders, and educators. Yes, and the inherent legacy of slavery and oppression. What is in a house?

I view this publication as a record of remarkable structures that spark emblems of life and how it was lived by African Americans from Reconstruction, Jim Crow, and through the civil rights era. It is a treasure to be shared across the globe. Often, unknowingly—and at times, intentionally—lives of persons who lived through oppression and went on to rise above go devalued and unappreciated. Yet they bear witness to what resilience, fortitude, and persistence can bring where there is determination to overcome, excel, and contribute. The state of Florida has numerous structures that are emblematic of such individuals and their uprising. This publication brings their significance and contributions out of the shadow. It begins with the Riley House, constructed around 1890 on the fringe of a community called Smokey Hollow. Here was a man, born into slavery in 1857, who rose to prominence as a school principal, a civic and church leader, property owner, and millionaire. His house is but one of the structures that grace the landscapes across Florida from which grew the black middle class.

To paraphrase my mentor in the historic preservation world, Donovan D. Rypkema, a principal at PlaceEconomics, "the houses in this publication invoke their relevance, and not only on architectural grounds. These are places that mattered, and matter, to local communities." From within these walls and panels emerged generations that scaled the walls of injustice to overcome.

What is in a house? It is the lineage of memories, lessons, community, inspiration, authenticity, and relevance today and for generations to come.

Althemese Pemberton Barnes
Founding director of John Gilmore Riley Center/Museum
and the Florida African American Heritage Preservation Network

ACKNOWLEDGMENTS

This book would not have been possible without my Lord and Savior, Jesus Christ. To my husband, Darryl Wright-Greene, my life has not been the same since we met in 2003. You have motivated me to go to places I never imagined. I love you more each day, and thank you for supporting me through this entire process. To my three children, your presence pushes me to higher places to leave you a legacy; thank you for your love. To my late grandmother Elnora Sampson and my late mother, Vivienner Grant, thank you for introducing me to history and museums and for planting seeds of greatness. Thank you to my late spiritual mother, Diane Grant, who pushed me to grow spiritually and believe God regardless of what is in front of me. There is a group of women who have prayed for me and supported me through this process, and I appreciate you all so much: Sharnelle Jones, Dr. Allison Wiley, Betty Ann-Landricks, and Denecia Gulley. To the late Gertrude Styles and Bethune Circle, thank you for introducing me to Mary McLeod Bethune and Bethune-Cookman University. My love for historic homes started when I walked into Mary McLeod Bethune's home. Dr. Ashley Robertson Preston and Dr. Tara White, words cannot express the appreciation I have for you both. Thank you for the late-night chats and for helping me understand more about history. Dr. Preston, thank you for introducing me to the many archives throughout Florida. Thank you to my group of sister/friends who have supported me through this process and my work since 1995: Sheryl Kincy, Monifa Madison, Lanita Parrish, Tonya Brown-Reeves, Cora Jakes Coleman, and Charkes Nesbitt. Carina Covington, thank you for your expertise in dealing with photographs. Michelle May, thank you for being my copy editor since 2009. Thank you to the many archives and museums throughout Florida. Special thanks to Terrance Cribbs-Lorrant, Dr. Dorothy Fields, Leona Cooper Baker, Althemese Barnes, Vedet Coleman-Robinson, Valada Parker Flewellyn, Lincolnville Museum and Cultural Center, Florida State Archives, Price Landrum, Vincent Birdsong, and Angel Prohaska and Katelyn Jenkins at Arcadia Publishing.

INTRODUCTION

Florida's Historic African American Homes began with my first steps in the home of Mary McLeod Bethune on the campus of Bethune-Cookman University. I arrived, still a teenager and freshman in college, possessing a strong desire and passion for working in this home that had been transformed into a foundation dedicated to the life and legacy of Mary McLeod Bethune in 1953. Bethune was an educator, activist, civil and human rights advocate, philanthropist, and founder of Bethune-Cookman. She not only opened a school for blacks, but she also opened a hospital and purchased beachfront land near Daytona Beach after a group of students were not able to visit a local beach. I grew to adore Mary McLeod Bethune, her spirit, determination, perseverance, faith in God, and her home, which led me to the journey of telling the story of Bethune's home and hundreds of others.

Florida has a rich history of blacks who were former slaves, entrepreneurs, politicians, business owners, educators, and real estate agents. The wealthy and successful black Floridians were determined to give other blacks opportunities for employment and home ownership. They did not stop with owning their personal residences or pushing for others to own, but purchased tracts of land at several beaches throughout the state, so blacks could enjoy the beach as a place of relaxation and reprieve from their daily lives. Millionaires from Jacksonville to Miami did not keep all of their wealth for themselves but possessed the spirit of philanthropy and humanitarian work.

Abraham Lincoln Lewis was a millionaire in Jacksonville who was the owner of the Afro-Life Insurance company, two homes, and a resort area for blacks who were not allowed to visit other public beaches in the area. John Riley was an educator who was born a slave, but by the end of his life, he was a millionaire who worked as a teacher and principal and acquired several pieces of land, one of which was his home in Tallahassee, which is still standing today. Elder Jordan was born into slavery but had the drive to become successful and was a millionaire by early adulthood. He opened the Jordan dance hall and owned a bus line, a beach, and land that was eventually used for homes for black families. Garfield Rogers owned a dry cleaning and tailoring business, two golf courses, and several other businesses, and was a partial owner and founder of the Central Life Insurance Company. He also invested in beachfront land for blacks near Daytona Beach. Rogers was instrumental in the construction of the Central Village homes for blacks in the Tampa area. D.A. Dorsey, the son of a sharecropper who worked as a carpenter and businessman, eventually owned land and businesses and designed and built his own home for his wife. Dorsey was also one of the first millionaires in Florida. He saw the need for blacks to further their education, and donated land for schools.

Dorothy Tookes, an ambitious and bold woman, transformed her home into a 17-room hotel that served African Americans who were not able to have accommodations during segregation in Tallahassee. Acclaimed guests such as James Baldwin and Louis Rawls rested in the Tookes Hotel. Tookes had the foresight to display a neon sign in 1952, when few signs of its kind existed in Tallahassee.

Throughout Florida history, we repeatedly find black millionaires not only gaining substantial wealth, but also supporting their families, friends, and employees. Some of the blacks were not able to own property but had to live in public housing that was not very high quality. Although they were not the owners of their residences, they had the utmost respect for their property and created their own slice of heaven. Others in Tampa and Miami lived in public housing that was not ideal but had a rich culture and family life, and a strong sense of community. Several of the public housing communities had essential businesses that served the community and provided entertainment. The Scrubs community in Tampa was one of the largest and oldest in the area. In the early 1900s, there were hundreds of black-owned businesses within the area that provided all of the vital elements needed for life and entertainment.

Many of the homes featured in this book are still standing. I strongly encourage you to visit your local historic district and educate yourself on the many residences that capture the history of blacks. The homes in this book span from the 19th century into the 20th century and reflect all walks of life. Not every home was owned by a prominent person; some were owned by people who worked hard to own property during times when it was more difficult being black. The beauty of each home in this book is that it tells the story of the owner. You can imagine how life was within the walls of the rooms, what aromas were in the kitchen, and what stories were shared in the living room. Even in the homes that were not large or did not have a famous owner, you can see the care the owners took of their property, from decorating the porch with flowers to maintaining the yard, you can see the expression of accomplishment on the faces of some owners as they are pictured in front of their residence. Former slaves, sharecroppers, laborers, domestic servants, educators, poets, artists, professors, politicians, businessmen, and women were all owners of homes in this book. The living quarters of these industrious, strong, resilient, determined, and ambitious African Americans are reflected in the values of today's homeowners. Their characteristics remain in the residences that still stand, and in the memories of those that are gone.

Please note that some of the homes in this book are privately owned and are not open to the public.

One

NORTH FLORIDA

North Florida is home to several cities including Pensacola, Tallahassee, and Jacksonville. Politicians, educators, and humanitarians who lived here contributed significantly to the advancement of African Americans in Florida. Edward Waters College and Florida Agricultural and Mechanical University are two historically black institutions that were established in the area, and on the campus of both schools were residences of notable African Americans. Two neighborhoods that are featured in this chapter—Smokey Hollow in Tallahassee and the Davis Street homes in Jacksonville—were communities that existed during the late 1890s and the early 1900s and were established due to segregation. Although segregation was the reason these communities existed, the people who lived there opened churches and businesses to meet their daily needs. This chapter features a cottage owned by a free woman of color, stately houses owned by doctors, and a home for the elderly in Jacksonville.

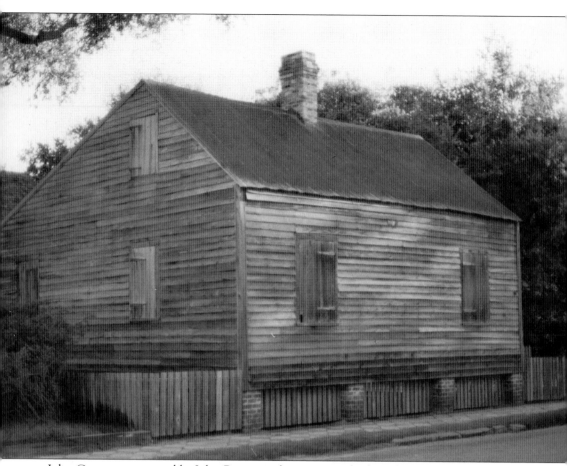

Julee Cottage was owned by Julee Panton, a free woman of color. The cottage was built around 1805 and constructed in a style reminiscent of a Creole cottage in the French Quarter of New Orleans. The cottage is unique in that it is built to the sidewalk, with no front porch. (Courtesy of University of West Florida Trust Archive.)

John Gilmore Riley was an educator, civic leader, and prominent citizen of Tallahassee. Riley was one of the few African Africans who owned property and several parcels of land, including his home. In 1892, he became principal of Lincoln Academy, a school for blacks, where he served until he retired in 1926. (Courtesy of the State Archives of Florida and John G. Riley Center & Museum.)

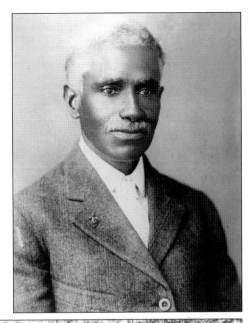

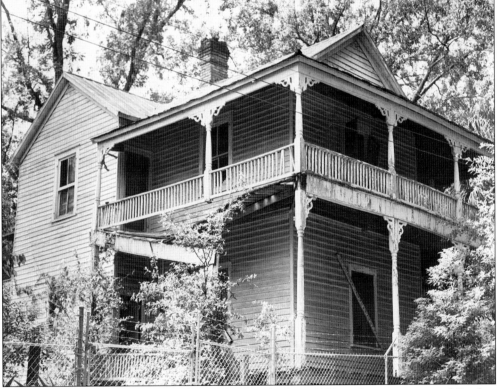

Pictured here is the John G. Riley home that was built in 1890 in the community of Smokey Hollow in Tallahassee. It is a prime example of an African American middle-class home of the time. The Riley home was listed in the National Register of Historic Places in 1978, and in 1996, it became a center that serves as a museum offering educational programs, exhibits, and research. (Courtesy of the State Archives of Florida and John G. Riley Center & Museum.)

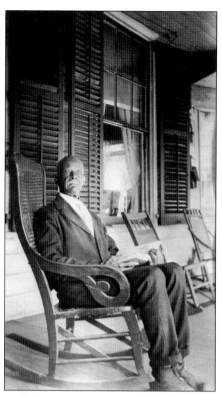

John E. Proctor was born a free man but was sold into slavery. He became a politician who served in the Florida House of Representatives and Senate. Proctor served five terms and was also a minister. (Courtesy of the State Archives of Florida.)

Pictured here is the home of John E. Proctor in Tallahassee. Standing next to Proctor in this photograph is his daughter Lettie Proctor Hill. Proctor died in 1944 at the age of 100. (Courtesy of the State Archives of Florida.)

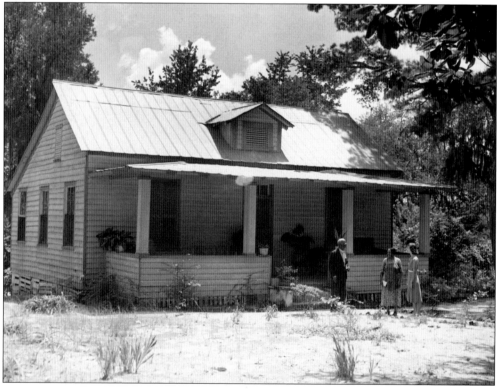

Thomas Van Renssalaer Gibbs was a politician who served in the Florida legislature and was an educator in Duval County. Gibbs wrote a bill to open two schools, one of which was a school for black students, the State Normal and Industrial College for Colored Students, today Florida Agricultural and Mechanical University. (Courtesy of the State Archives of Florida.)

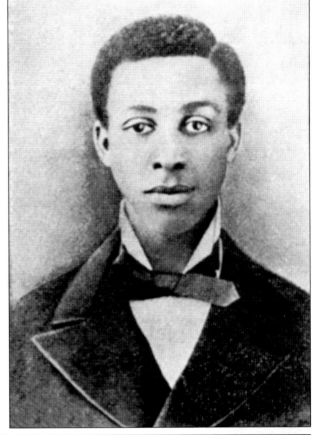

Pictured here is Gibbs Cottage, home of Thomas Van Renssalaer Gibbs. The cottage was built around 1892 and is one of the oldest remaining wooden buildings on the campus of Florida Agricultural and Mechanical University. (Courtesy of the State Archives of Florida.)

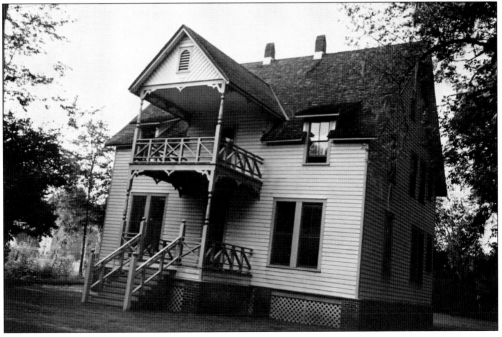

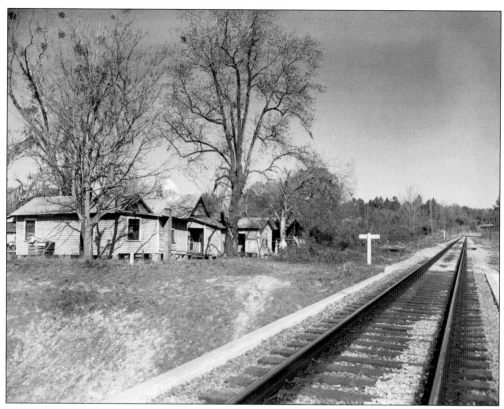

Smokey Hollow was a black neighborhood in Tallahassee created around the 1890s. The area was known for a consistent haze of smoke from chimneys. Pictured here is a row of houses on January 22, 1960. (Courtesy of the State Archives of Florida.)

Pictured here is a home in the Smokey Hollow neighborhood. This photograph was taken on January 3, 1963. Smokey Hollow was designated a historic district on October 27, 2000. (Courtesy of the State Archives of Florida.)

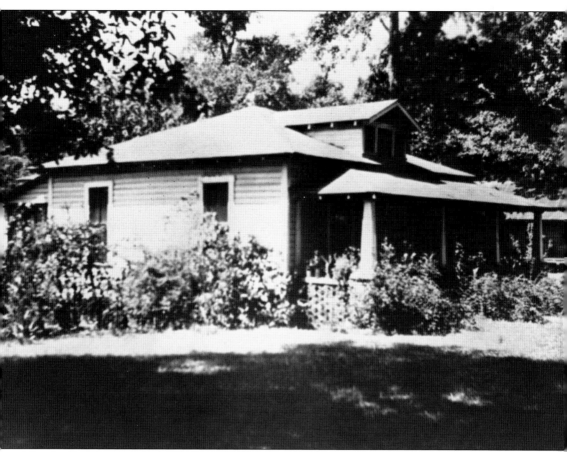

John Swilley was a master bricklayer who assisted in constructing many buildings in Tallahassee and was the second black hired to teach bricklaying at the Federal Correctional Institution. Pictured here is his home on East Saint Augustine Road in Tallahassee. (Courtesy of State Archives of Florida.)

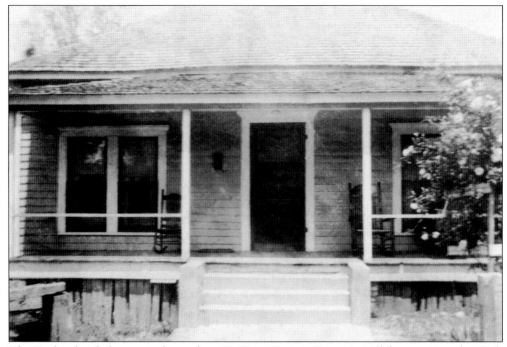

The Tookes family home was located at 412 West Virginia Street in Tallahassee. Dorothy Nash Tookes transformed the home into a hotel for blacks who were not able to find other lodging while visiting the area. (Courtesy of State Archives of Florida.)

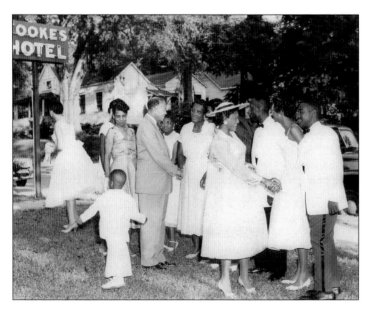

Dorothy Nash Tookes was the founder of the Tookes Hotel and the principal of Bonds Elementary in 1935. From 1948 to the mid-1980s, famous blacks, including James Baldwin, were guests at the Tookes Hotel. Pictured here at center is Nash greeting guests at her son's wedding at the hotel. (Courtesy of State Archives of Florida.)

George Gore was the fifth president of
Florida Agricultural and Mechanical
University. He served as president
from 1950 to 1968 and lived in the
president's residence on campus.
(Courtesy of State Archives of Florida.)

Sunshine Manor, on the campus of Florida
Agricultural and Mechanical University
in Tallahassee, is where George Gore lived
during his presidency at the university.
(Courtesy of State Archives of Florida.)

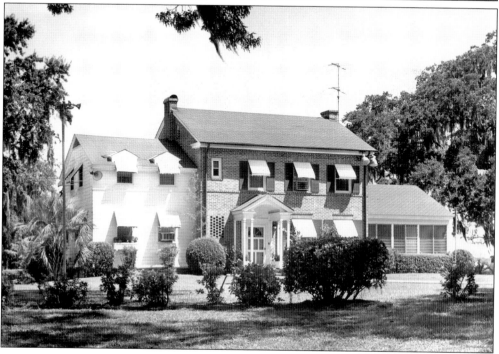

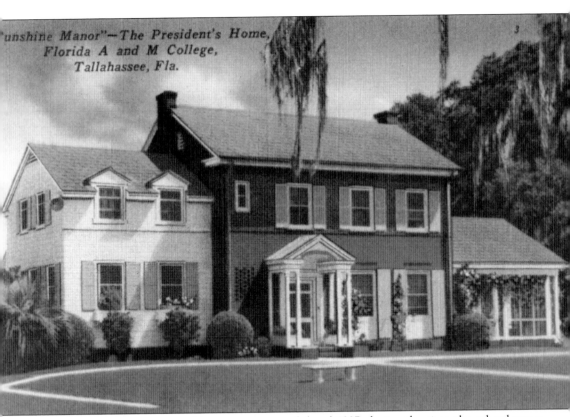

"unshine Manor"—The President's Home,
Florida A and M College,
Tallahassee, Fla.

Sunshine Manor is pictured here on a postcard dated 1937, during the time the school was a college. (Courtesy of State Archives of Florida.)

The LaVilla area was an incorporated town for newly freed blacks after the Civil War. After operating as a town for 10 years, it was annexed into the city of Jacksonville. Pictured here is a cabin in LaVilla around 1870. (Courtesy of State Archives of Florida.)

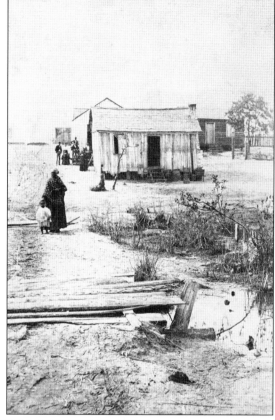

W.W. Andrews Sr. was the Florida grand chancellor of the Knights of Pythias, an international fraternal organization. Pictured here in 1919 is the office of the Florida lodge and the Andrews residence. From left to right are Cyril B. Andrews, Henrietta G. Smith Andrews, W.W. Andrews Jr., and W.W. Andrews Sr. (Courtesy of the State Archives of Florida.)

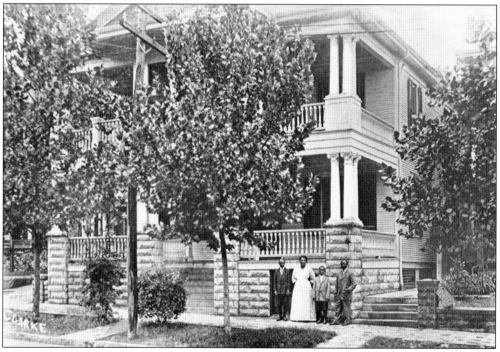

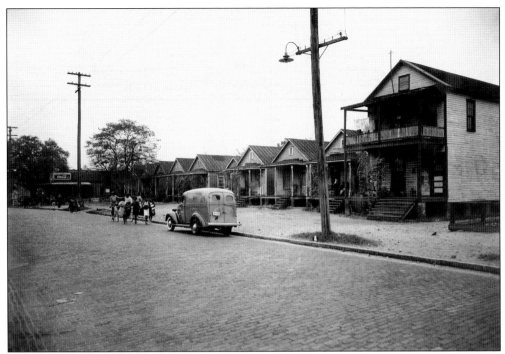

The Davis Street homes in Jacksonville were shotgun houses, typical residences for blacks in the South during the 1940s. Pictured here are homes on Davis Street near the Sugar Hill neighborhood. (Photograph by John Gordon "Jack" Spottswood, courtesy of State Archives of Florida.)

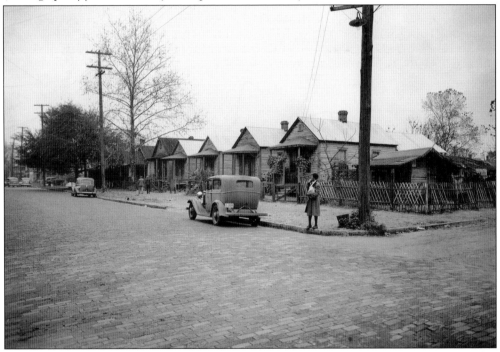

Pictured here is a woman standing on the corner of Davis Street near shotgun homes in December 1941. (Photograph by John Gordon "Jack" Spottswood, courtesy of State Archives of Florida.)

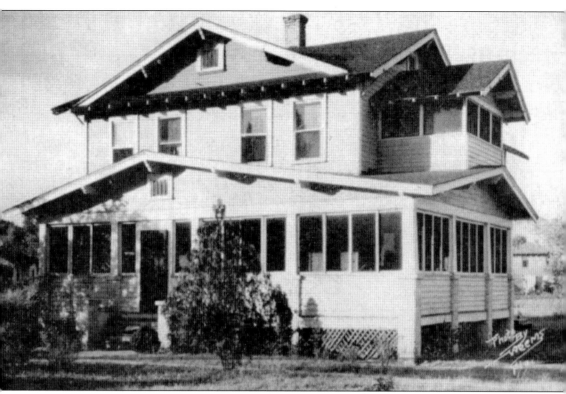

Edward Waters College was established in 1865 in Jacksonville by the African Methodist Episcopal Church as an institution for blacks. It was Florida's first school for blacks. Pictured here is the residence of President Howard D. Gregg and his wife on the campus. Gregg was the 17th president of the college, serving from 1940 to 1942. (Courtesy of the Eartha M.M. White Collection, Thomas G. Carpenter Library, University of North Florida.)

Bishop Henry Young Tookes, an alumnus of Edward Waters College, served as chancellor for the college and president of the Board of Church Extension and as a bishop in the African Methodist Episcopal Church. Tookes was instrumental in acquiring property for the construction of new buildings, including a dormitory and the J.W. Wise stadium, on the campus of Edward Waters College. (Courtesy of the Eartha M.M. White Collection, Thomas G. Carpenter Library, University of North Florida.)

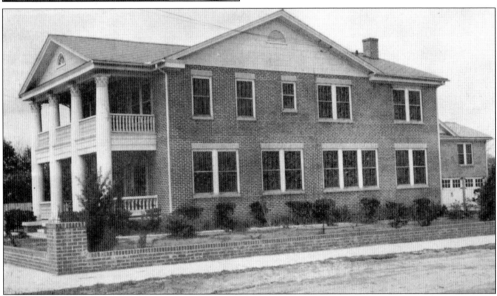

The residence of Bishop Henry Young Tookes is at 1011 West Eighth Street in the Sugar Hill neighborhood of Jacksonville. Tookes and his wife, Maggie, built this home in 1939. It was purchased and renovated by the Gamma Rho Omega chapter of Alpha Kappa Alpha sorority, founded in 1908 on the campus of Howard University. It is one of the few remaining large houses that survived expansion within the city of Jacksonville. (Courtesy of the Eartha M.M. White Collection, Thomas G. Carpenter Library, University of North Florida.)

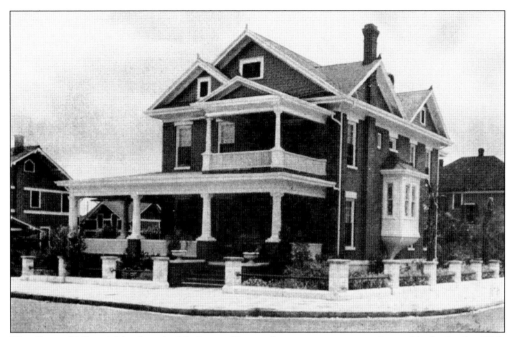

The Sugar Hill neighborhood of Jacksonville was home to many prominent blacks in the 19th and early 20th centuries. The residence pictured here was at 852 West Eighth Street and owned by Lawson Pratt and his wife. (Courtesy of the Eartha M.M. White Collection, Thomas G. Carpenter Library, University of North Florida.)

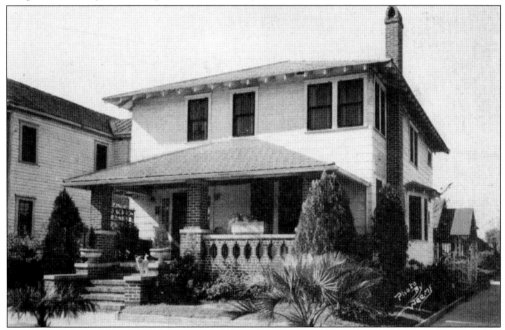

Dr. William L. Redmond and his wife owned this home at 2028 Davis Street in Jacksonville. Dr. Redmond was a 1926 graduate of Meharry Medical College, a historically black college, and a member of Kappa Alpha Psi fraternity, a historically black fraternity. (Courtesy of the Eartha M.M. White Collection, Thomas G. Carpenter Library, University of North Florida.)

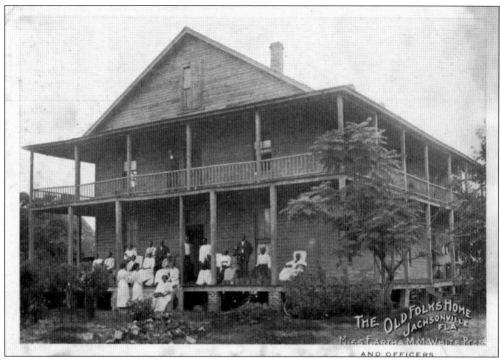

Eartha M.M. White was a prominent Jacksonville businesswoman and philanthropist known for her many humanitarian efforts in the area. This postcard shows an "Old Folks Home" White opened for elderly blacks who lived in poverty. (Courtesy of the Eartha M.M. White Collection, Thomas G. Carpenter Library, University of North Florida.)

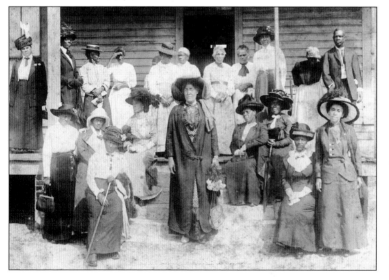

Margaret Murray Washington is pictured here visiting the Old Folks Home in March 1913. William R. Cole, a Jacksonville photographer, captured her visit. (Courtesy of the Eartha M.M. White Collection, Thomas G. Carpenter Library, University of North Florida.)

Two

LINCOLNVILLE, AMERICAN BEACH, AND BUTLER BEACH

North Florida is home to several neighborhoods and beaches that were primarily African American. The Lincolnville community in St. Augustine was founded in 1866 by former slaves. It was home to many politicians and prominent African Americans, and was important during the civil rights movement. Two businessmen, Frank Butler of the Lincolnville community in St. Augustine and A.L. Lewis of Jacksonville, were pivotal in the advancement of African Americans in the area. Lewis, the first African American millionaire in Florida, owned a home in Jacksonville as well as the first beach house on American Beach. American and Butler Beaches were the results of the agenda set by Lewis and Butler as places for the enjoyment for blacks.

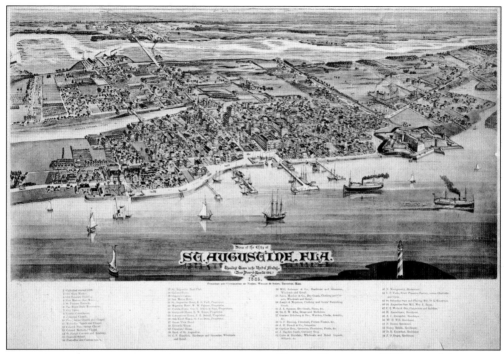

Pictured here is an 1885 map of St. Augustine. The Lincolnville community was a predominantly African American area with churches, schools, businesses, and residences. (Courtesy of the State Archives of Florida.)

Frank Butler was the president of College Park Realty Company. Pictured here is an advertisement to rent, buy, or sell property for African Americans in "a colored subdivision." (Courtesy of the State Archives of Florida.)

Lincolnville homeowners included several African American women. Pictured here is Mary "Mae" Martin standing outside the gate to her home. (Photograph by Richard A. Twine, courtesy of the Richard A. Twine Collection, St. Augustine Historical Society.)

In this 1922 photograph, Mary "Mae" Martin is reading a book in her parlor. (Photograph by Richard A. Twine, courtesy of the Richard A. Twine Collection, St. Augustine Historical Society.)

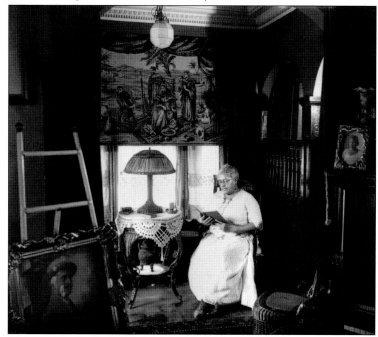

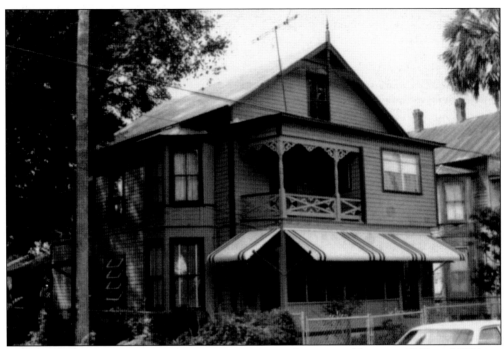

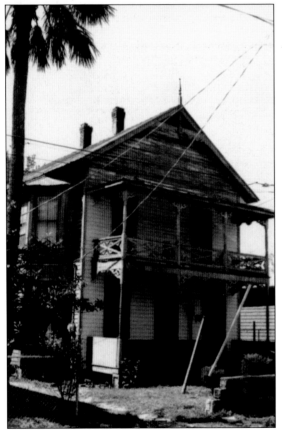

Constructed between 1888 and 1894, the home at 109 DeHaven Street was in the Lincolnville community. The frame vernacular structure was the residence of black physician and surgeon Dr. David H. Brown in the 19th century. (Courtesy of Florida Master Site File, Florida Division of Historical Resources.)

Dr. Edward A. Waters, a black dentist, was once the owner of this house at 111 DeHaven Street in Lincolnville. It was one of the original structures in the subdivision of Atwood Tract. (Courtesy of Florida Master Site File, Florida Division of Historical Resources.)

This house at 112 Moore Street in St. Augustine was built between 1904 and 1910. Once a school for blacks, it was converted into a residence around 1930 and was owned by the widow of a former principal of another black school in the area. (Courtesy of Florida Master Site File, Florida Division of Historical Resources.)

Alonzo Douglas, a black man who was the secretary of the Home Circle Publishing Company, owned this house at 64 Oneida Street in Lincolnville. It was built between 1871 and 1885 and was one of the original structures in the area. (Courtesy of Florida Master Site File, Florida Division of Historical Resources.)

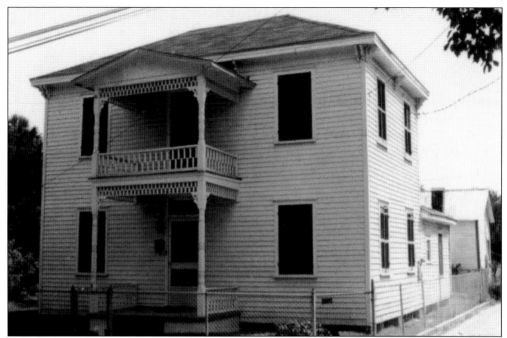

This house at 95 Oneida Street in the Lincolnville community was once owned by A.A. Pappy, a black man who was the city assessor and owned a barbershop. It was built between 1871 and 1885, one of the original structures in Lincolnville. (Courtesy of Florida Master Site File, Florida Division of Historical Resources.)

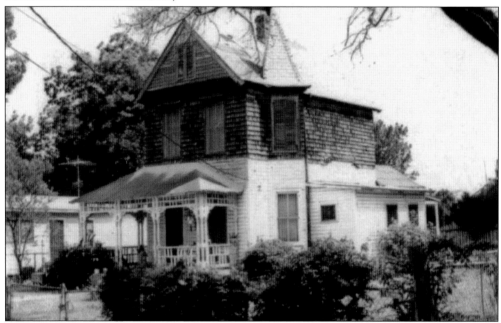

In 1911, this home at 139 Oneida Street was owned by black baker Charles G. Gibson. It was constructed between 1885 and 1894. The frame vernacular structure features Victorian components and turned spindle posts. (Courtesy of Florida Master Site File, Florida Division of Historical Resources.)

Frank Butler was a resident of the Lincolnville community in St. Augustine. A successful businessman who owned a market and real estate, he was active in politics and civic and religious activities in the community. (Courtesy of the Frank Butler family.)

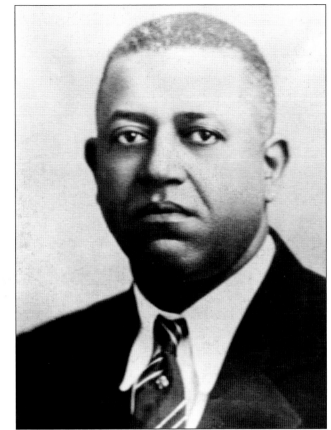

Frank Butler owned this home in Lincolnville. The two-story structure was built around 1906 and was Butler's residence and the location of the office for College Park Realty Company. (Courtesy of Florida Master Site File, Florida Division of Historical Resources.)

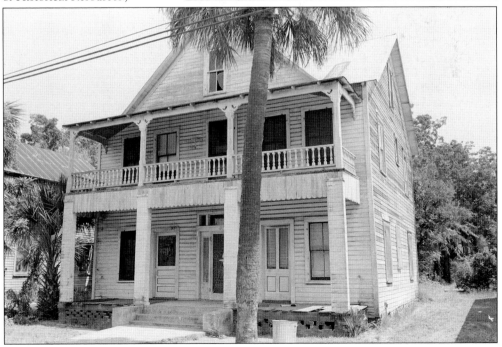

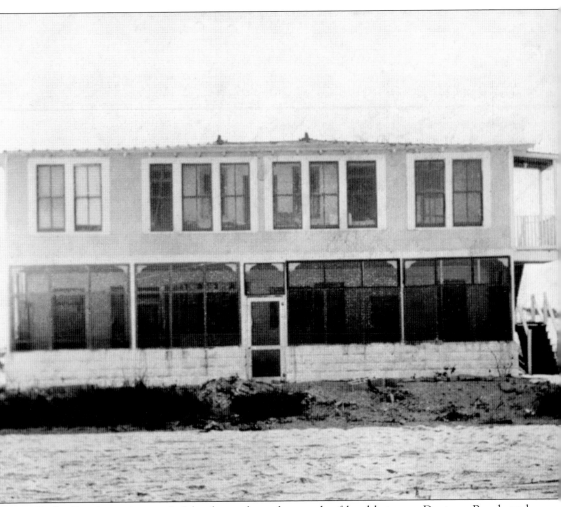

Butler Beach on Anastasia Island was the only stretch of land between Daytona Beach and American Beach in Jacksonville that was designed for blacks and purchased by Frank Butler. Pictured here is Butler's beach house on the island. (Courtesy of the State Archives of Florida.)

Pictured here in 1960 are homes along Butler Beach on Anastasia Island. Frank Butler developed the beachfront area to have homes, bathhouses, and black-owned businesses. (Courtesy of the State Archives of Florida.)

Abraham Lincoln Lewis was born in 1865 in Madison County, and his family relocated to Jacksonville in 1876. Lewis and six other prominent African Americans founded the Afro-American Life Insurance Company. Lewis became president and ultimately was the first African American millionaire in the state. (Courtesy of the State Archives of Florida.)

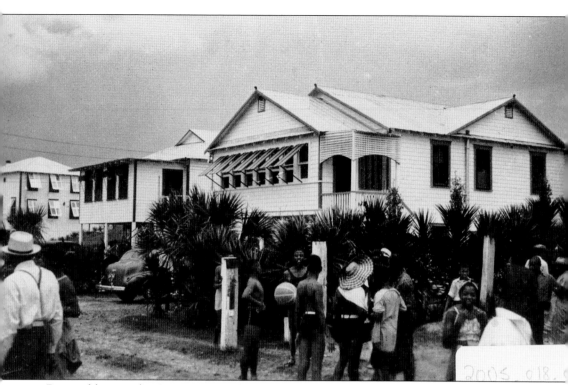

Pictured here is the American Beach residence of Abraham Lincoln Lewis. Lewis built this oceanfront house on the black beach that was purchased by Lewis and the Afro-American Life Insurance Company. (Courtesy of the Amelia Island Museum of History.)

Three

GAINESVILLE AND OCALA

Gainesville has a vibrant history of African American business owners, politicians, and entrepreneurs. In the archives of the University of Florida, a postcard collection was discovered featuring homes owned by African Americans. Although no dates were documented, through research of Alachua County deed records, some of the names of the owners of these homes (as indicated on the postcards) match the period of the early to mid-1900s. The Ocala area of Marion County is listed in the 1872 census as having a population of 73 percent blacks, and 65 percent of registered voters in the county were blacks. The thriving community included several businesses, and the only bank to ever be chartered to African Americans by the state of Florida was in the city of Ocala. West of the downtown area was home to middle-class African Americans who were doctors, leaders, and businessmen.

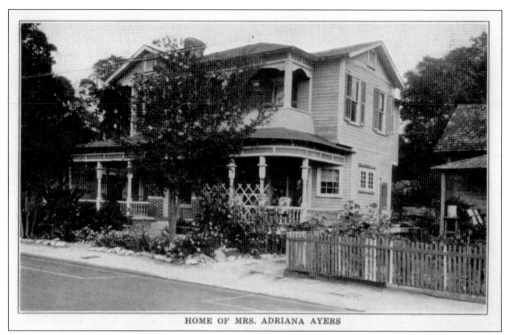

HOME OF MRS. ADRIANA AYERS

This was the home of Adriana Ayers in the African American area of Gainesville. A woman stands on the porch. (Courtesy of the A. Quinn Jones Collection, George A. Smathers Libraries.)

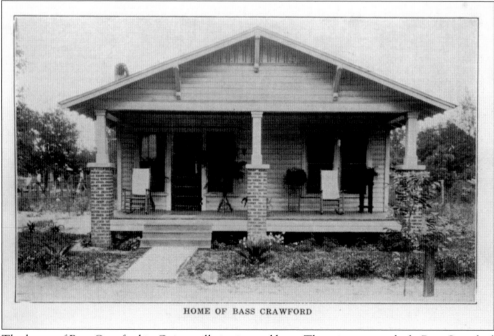

HOME OF BASS CRAWFORD

The home of Bass Crawford in Gainesville is pictured here. There is no record of a Bass Crawford in the Alachua County deed records; however, it could have been a spouse not listed in the records. (Courtesy of the A. Quinn Jones Collection, George A. Smathers Libraries.)

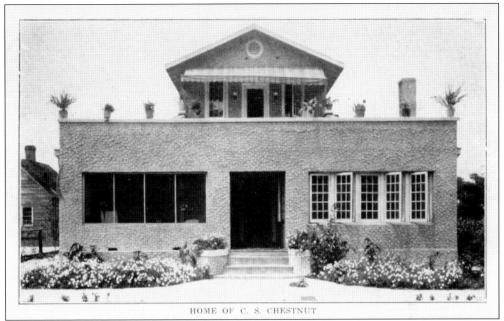

HOME OF C. S. CHESTNUT

Here is the home of C.S. Chestnut in Gainesville. Chestnut was presumably part owner of the Hughes and Chestnut funeral home that was established in 1914. (Courtesy of the A. Quinn Jones Collection, George A. Smathers Libraries.)

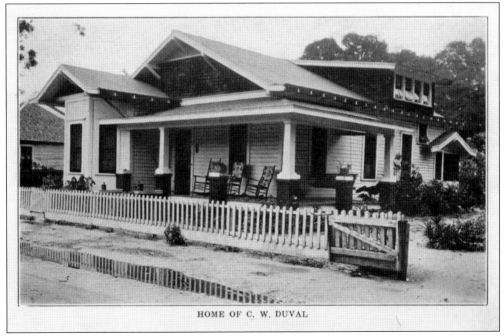

HOME OF C. W. DUVAL

Charles W. Duval was the owner of a shoe repair shop in Gainesville. His store was the first black-owned business in the downtown area. Duval's home was one of many in the Pleasant Street area. (Courtesy of the A. Quinn Jones Collection, George A. Smathers Libraries.)

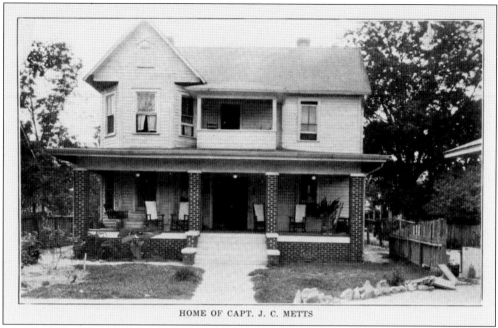

HOME OF CAPT. J. C. METTS

This house at 730 Northwest Second Street in the Pleasant Street area of Gainesville was built in 1891. Capt. J.C. Metts was a local grocery store owner. (Courtesy of the A. Quinn Jones Collection, George A. Smathers Libraries.)

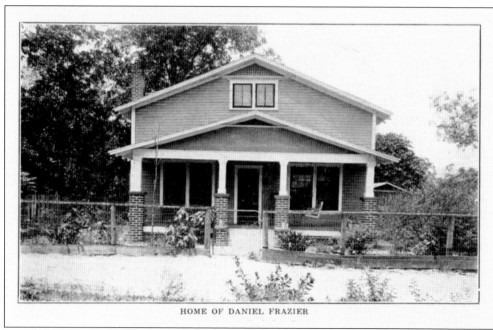

HOME OF DANIEL FRAZIER

According to the postcard, this was the home of Daniel Frazier. There is no record of a home owned by anyone of that name in the county deed records. (Courtesy of the A. Quinn Jones Collection, George A. Smathers Libraries.)

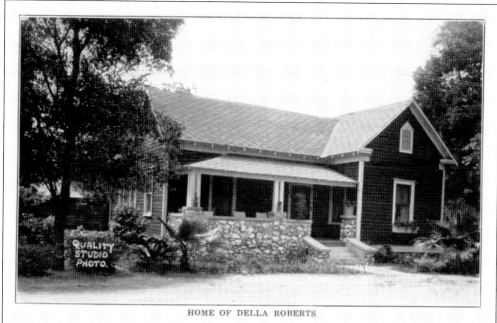

HOME OF DELLA ROBERTS

Della Roberts was the owner of this house. There is no mention of her in the county records. (Courtesy of the A. Quinn Jones Collection, George A. Smathers Libraries.)

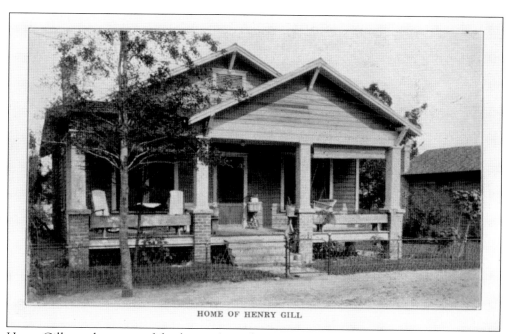

HOME OF HENRY GILL

Henry Gill was the owner of this home. According to county records, Gill was officially deeded the home on July 16, 1919, in Gainesville. (Courtesy of the A. Quinn Jones Collection, George A. Smathers Libraries.)

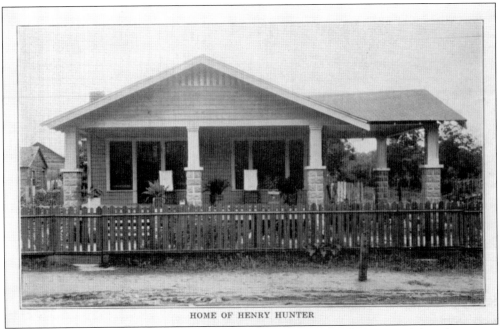

HOME OF HENRY HUNTER

Henry Hunter was listed as the owner of the house pictured on this postcard, but there is no mention of him in the county deed records. (Courtesy of the A. Quinn Jones Collection, George A. Smathers Libraries.)

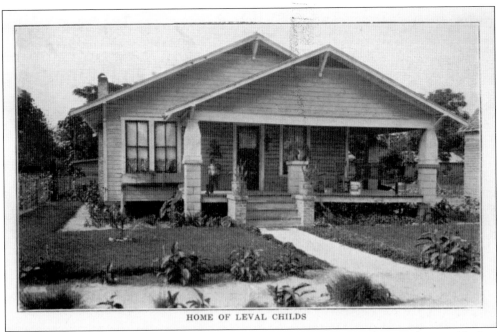

HOME OF LEVAL CHILDS

Pictured here is the home of Leval Childs, as indicated on the postcard. According to Alachua County deed records, there was no residence owned by anyone of that name. (Courtesy of the A. Quinn Jones Collection, George A. Smathers Libraries.)

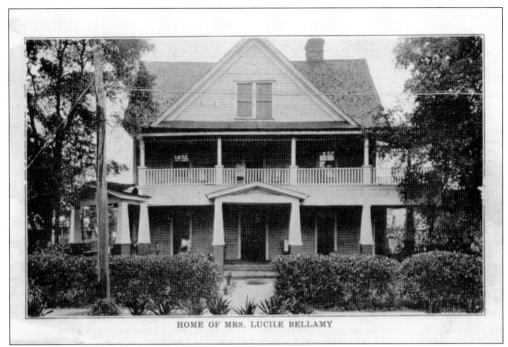

HOME OF MRS. LUCILE BELLAMY

Lucile Bellamy, a black woman, was the owner of the house pictured here in the Pleasant Street area of Gainesville. (Courtesy of the A. Quinn Jones Collection, George A. Smathers Libraries.)

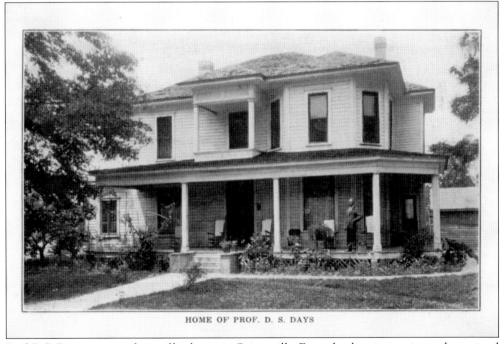

HOME OF PROF. D. S. DAYS

Prof. D.S. Days is seen in front of his home in Gainesville. From the description, it was determined that the house was in the Pleasant Street neighborhood. (Courtesy of the A. Quinn Jones Collection, George A. Smathers Libraries.)

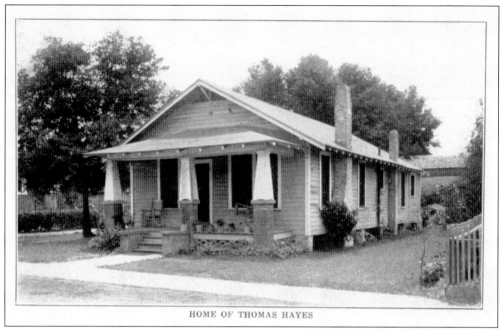

HOME OF THOMAS HAYES

Alachua County records reveal that this home was owned by Thomas Hayes. It was located on two lots in July 1927. (Courtesy of the A. Quinn Jones Collection, George A. Smathers Libraries.)

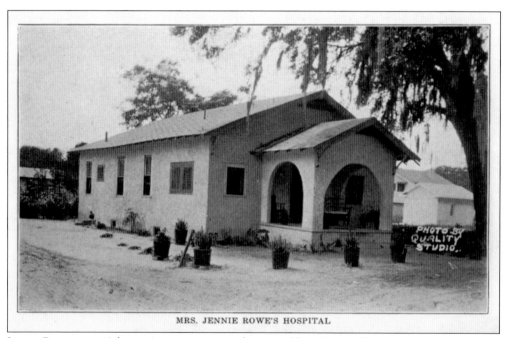

MRS. JENNIE ROWE'S HOSPITAL

Jennie Row was an African American nurse who turned her Gainesville home into a hospital for blacks from 1917 to 1929. Pictured here is the home at 901 Northwest Third Avenue. (Courtesy of the A. Quinn Jones Collection, George A. Smathers Libraries.)

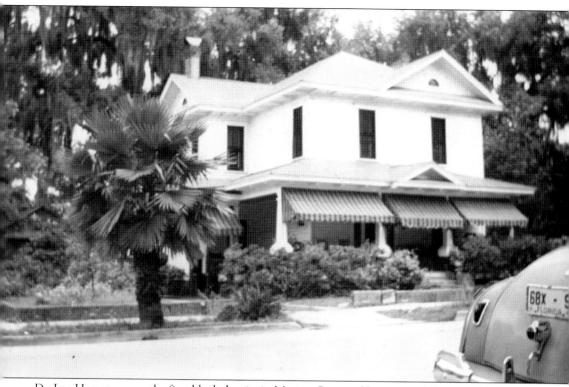

Dr. Lee Hampton was the first black dentist in Marion County. He practiced dentistry from 1913 to 1935 in the Ocala community. Today, the Hampton Center at the College of Central Florida is named in his honor. (Courtesy of Marion County Public Library and Price Landrum, Marion County Museum of History and Archaeology.)

Pictured here is a dwelling in West Ocala, one of many homes in the community owned by well-established black families in the early 20th century. (Courtesy of Marion County Public Library and Price Landrum, Marion County Museum of History and Archaeology.)

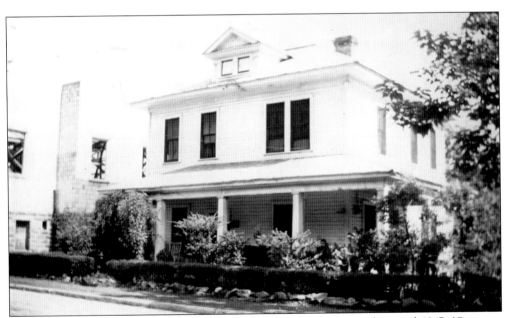

This stately home was in the West Ocala neighborhood. It is pictured around 1947. (Courtesy of Marion County Public Library and Price Landrum, Marion County Museum of History and Archaeology.)

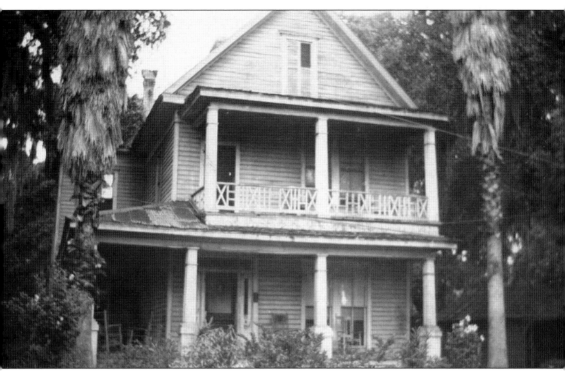

This two-story residence, whose owner is unknown, was in West Ocala. This photograph is dated around 1947. (Courtesy of Marion County Public Library and Price Landrum, Marion County Museum of History and Archaeology.)

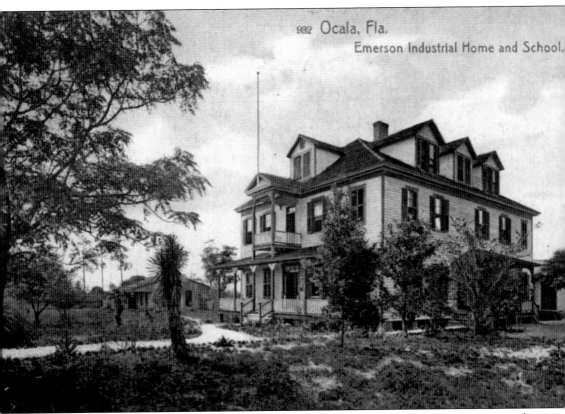

The Emerson Industrial Home and School was an Ocala institution for African American girls. The students lived in the school building. (Courtesy of Price Landrum, President, Marion Country Museum of History and Archaeology.)

Four

DAYTONA BEACH

Daytona Beach has been known historically as home to the "World's Most Famous Beach." It is also the location of Bethune-Cookman College. Mary McLeod Bethune opened a school in 1904 called the Daytona Educational and Industrial Training for Negro Girls at the city dump. In 1923, the school merged with the Cookman Institute, which was originally in Jacksonville, and became known as Bethune-Cookman College. Mary McLeod Bethune was ahead of her time and was successful in raising money from the wealthy white vacationers in the area. She was not only an educator but a philanthropist and civil rights activist and was appointed an adviser to Pres. Franklin D. Roosevelt. She contributed greatly to the community of Daytona Beach with the opening of the only black hospital, McLeod Hospital, and purchased land south of New Smyrna Beach to open Bethune Beach for blacks. This chapter explores the home of Mary McLeod Bethune on the campus of Bethune-Cookman, the life of blacks in the area during the 1940s, and Dr. Howard Thurman.

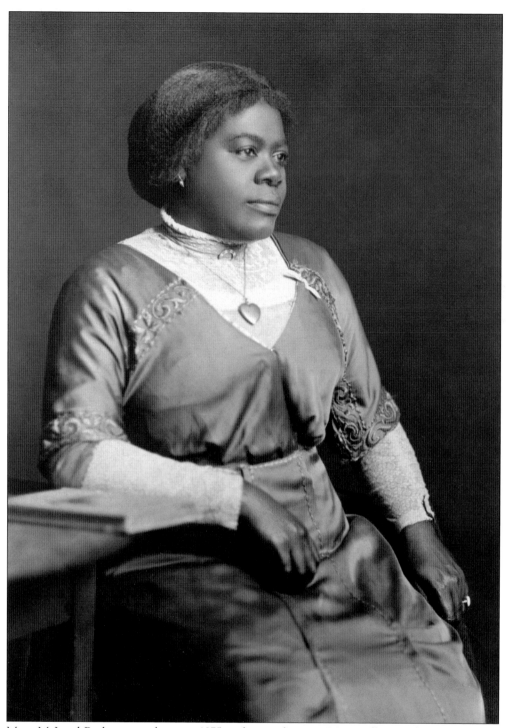

Mary McLeod Bethune was born in 1875 to former slaves in Mayesville, South Carolina. She became an educator and eventually moved to Florida, where she started a school in Daytona Beach with five little girls, faith in God, and $1.50. She was a champion of education and a better way of life for blacks. (Courtesy of the State Archives of Florida.)

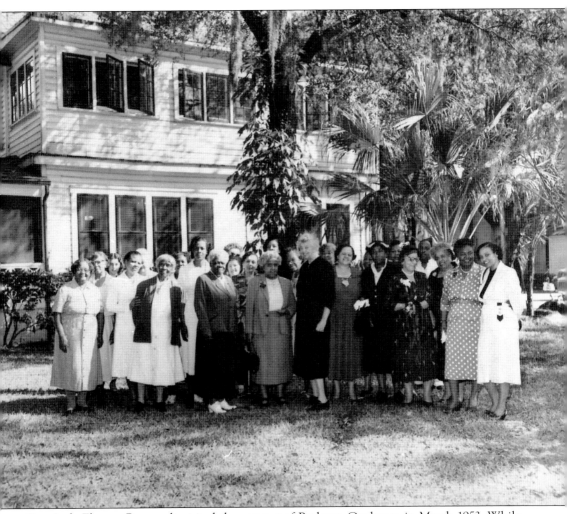

First Lady Eleanor Roosevelt visited the campus of Bethune-Cookman in March 1953. While visiting, she was a guest at the home of Mary McLeod Bethune. Pictured here in the front row of a group of women after breakfast at the home are, from left to right, Mary McLeod Bethune, alumnae and donor Marjorie Joyner, and Roosevelt. (Courtesy of the State Archives of Florida.)

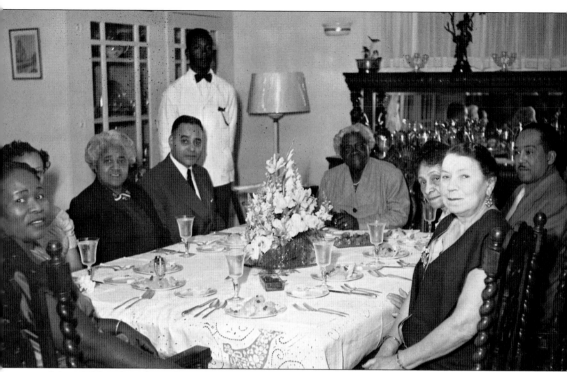

Mary McLeod Bethune hosted many guests at her home on the campus of Bethune-Cookman. Pictured here is a dinner that Bethune hosted in her dining room. Among those seated are Arrabella Dennison, Marjorie Joyner, Ralph Bunche, and Mary McLeod Bethune. (Courtesy of the State Archives of Florida.)

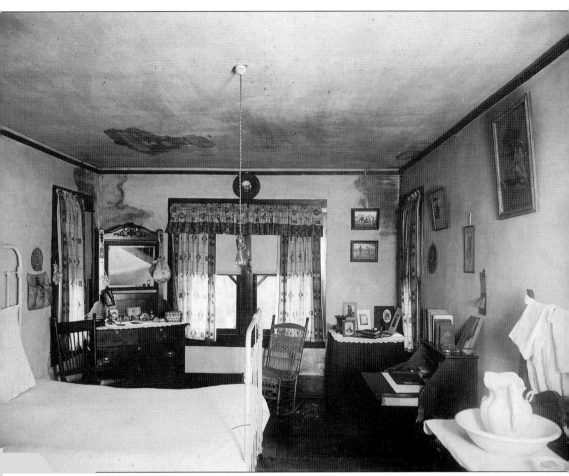

Pictured here is a bedroom in Mary McLeod Bethune's home. The photograph above the bed is of Mary's parents, Sam and Patsy McLeod, former slaves in South Carolina. (Courtesy of Bethune-Cookman University Archives.)

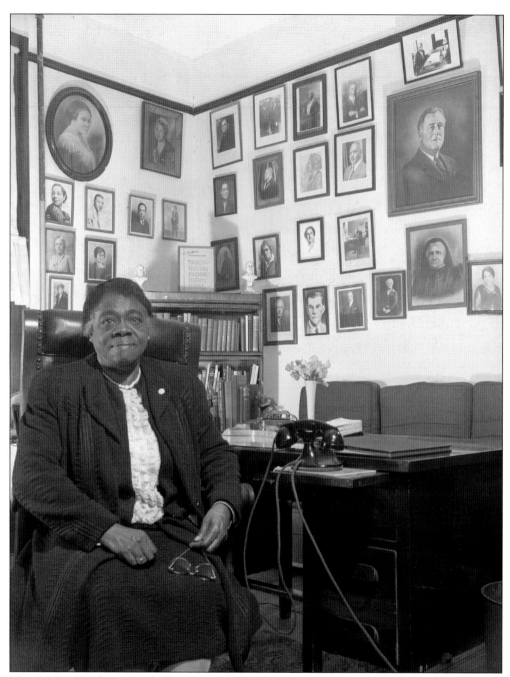

Mary McLeod Bethune was the former president and director of the National Youth Administration, Negro Division, which was a federal agency under President Roosevelt in 1936. Pictured here is Bethune, seated in her home office in Daytona Beach. (Photograph by Gordon S. Parks, courtesy of the Farm Security Administration–Office of War Collection, Prints & Photographs Division, Library of Congress, LC-USW3- 014843-C.)

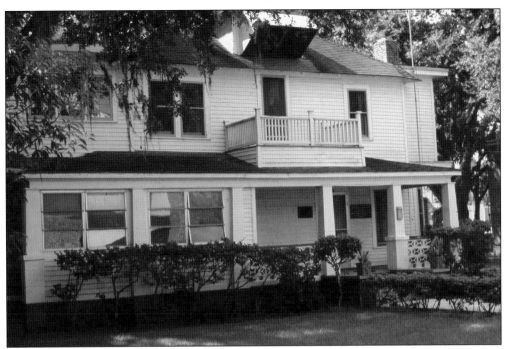

The home of Dr. Mary McLeod Bethune on the campus of Bethune-Cookman University was listed in the National Register of Historic Places in 1974. It was also listed as a National Historic Landmark in 1974. (Photograph by Karl Holland, courtesy of the State Archives of Florida.)

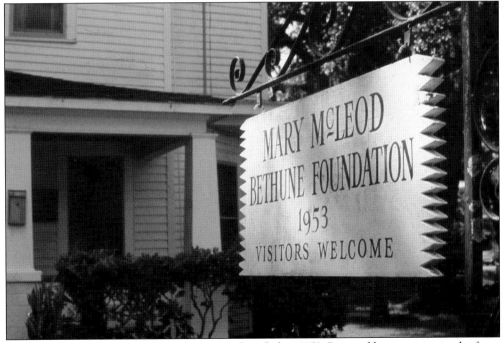

The Mary McLeod Bethune Foundation was founded in 1953. Pictured here is a sign in the front of the home welcoming visitors. (Photograph by Karl Holland, courtesy of the State Archives of Florida.)

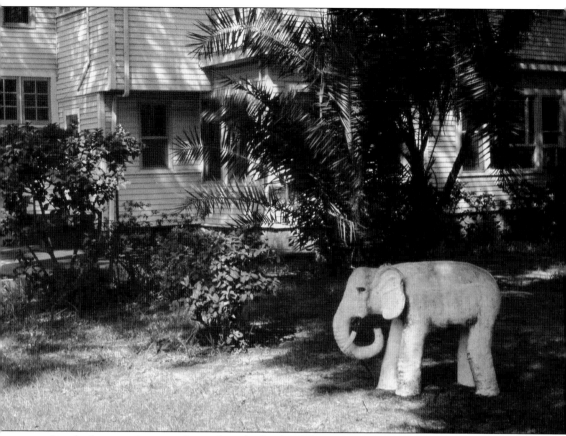

An elephant sculpture is located at the back of the Mary McLeod Bethune home. Bethune was an extensive collector of walking canes and elephants, which are displayed throughout her home. She admired elephants for their strength and powers of memory. (Courtesy of the State Archives of Florida.)

As woman before her time, Mary McLeod Bethune is pictured here standing next to a sign that reads, "Mary McLeod Bethune Foundation 1953 / Not For Myself But For Others." Prior to her death in 1955, Bethune created a foundation to preserve her residence and legacy. (Courtesy of Bethune-Cookman University Archives.)

Howard Thurman was one of the most important preachers and leaders in the social justice movement in the 20th century. He was a mentor to Dr. Martin Luther King Jr. and one of the most prolific voices in the black church. Thurman was a dean of Rankin Chapel from 1932 to 1944 at Howard University, one of the most well-known historically black institutions. (Courtesy of the State Archives of Florida.)

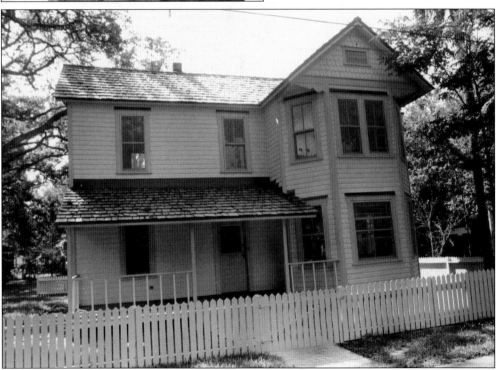

Howard Thurman was born in this home at 614 Whitehall Avenue in Daytona Beach. He lived here throughout his childhood, and he recalled having "uplifting spiritual experiences" under an oak tree in the backyard. (Courtesy of the Howard Thurman Home and the Florida Master Site File, Florida Division of Historical Resources.)

Daytona Beach had several black communities. In this photograph, low-rent housing for blacks was located near the campus of Bethune-Cookman. (Photograph by Gordon S. Parks, courtesy of the Farm Security Administration–Office of War Collection, Prints & Photographs Division, Library of Congress, LC-USW3-017038-E.)

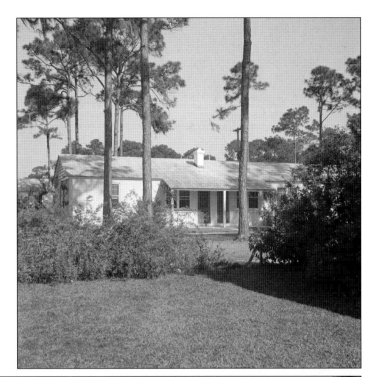

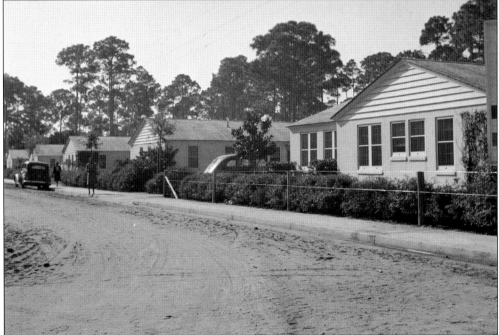

The Pinehaven community was a development of the housing authority of Daytona Beach. As part of the low-rent housing program of the US Housing Authority, the homes were designed for blacks to have affordable housing. (Photograph by Gordon S. Parks, courtesy of the Farm Security Administration–Office of War Collection, Prints & Photographs Division, Library of Congress, LC-USW3-017029-E.)

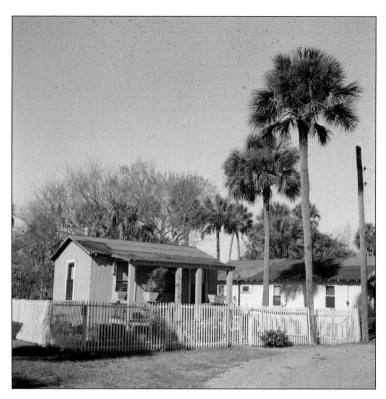

This single-family home is in the Daytona Beach area. It was described as being in the "Negro section" around 1943. (Photograph by Gordon S. Parks, courtesy of the Farm Security Administration–Office of War Collection, Prints & Photographs Division, Library of Congress, LC-USW3-017022-E.)

This two-story home was also described at the time of the photograph as being in the Negro section of Daytona Beach. Several area homes were documented by the famous African American photographer Gordon Parks. (Photograph by Gordon S. Parks, courtesy of the Farm Security Administration–Office of War Collection, Prints & Photographs Division, Library of Congress, LC-USW3-017032-E.)

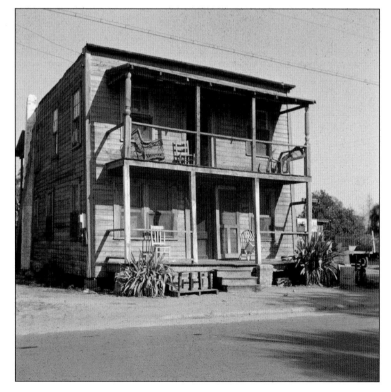

Five

CENTRAL FLORIDA

Joseph N. Crooms, L.B. Brown, and Zora Neale Hurston are just a few of the prominent people who have lived in central Florida. From Sanford to Tampa, many residences were home to former slaves, artists, poets, politicians, activists, educators, and domestic workers. The extraordinary history of Zora Neale Hurston and Eatonville can be found on the roads through central Florida. Eatonville was one of the first black communities, incorporated in 1887. African Americans who were free successfully established the town, with all leaders of African descent. One of the most famous residents as a child was Zora Neale Hurston, whose father was the mayor of the town. Several neighborhoods in the Tampa region were full of culture, wealthy blacks, and entertainment. The Ybor City neighborhood was home to Afro-Cuban and British blacks in the early 1900s. College Hill in West Tampa was one of the black communities that were not surrounded by railroads or bodies of water. The neighborhood had the largest population of blacks during the 1920s. In the West Palm Avenue area of Tampa, blacks were homeowners, and some homes were rental properties. Unlike College Hill, this neighborhood was surrounded by businesses and a river. The homes of central Florida's wealthy businessmen, former slaves, and educators are explored in this chapter.

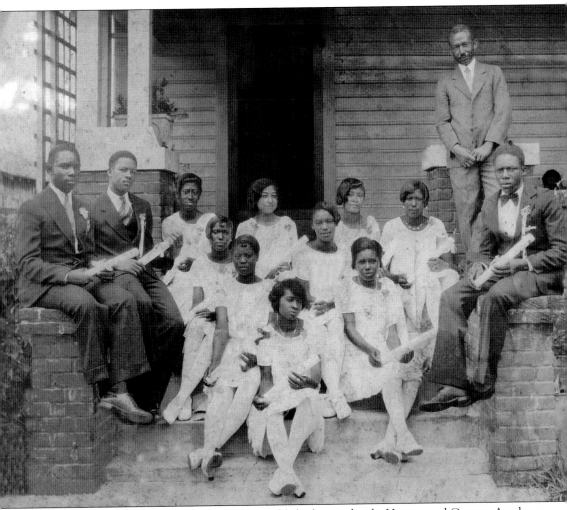

Joseph N. Crooms was an educator who established two schools, Hopper and Crooms Academy, for black students in Seminole County. He stands in this photograph with the 1929 graduating class of Crooms Academy. Crooms and the students are on the front porch of his home at 812 South Sanford Avenue in Sanford. (Courtesy of the Sanford Museum.)

F.H. Harris was a resident of Sanford in 1893. He was married with a family and owned his own property in the city. (Courtesy of the Sanford Museum.)

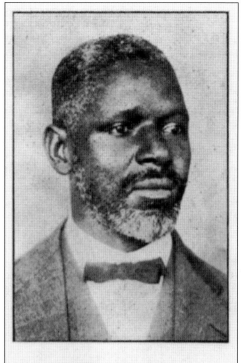

F. H. Harris

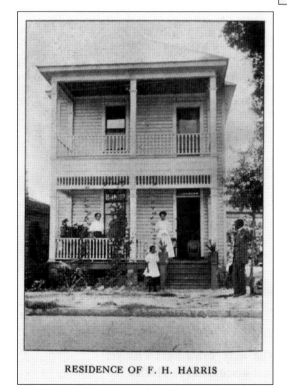

RESIDENCE OF F. H. HARRIS

F.H. Harris, his wife, and children are pictured here on the front porch of their home, also known as the Harris Nest, in Sanford. (Courtesy of the Sanford Museum.)

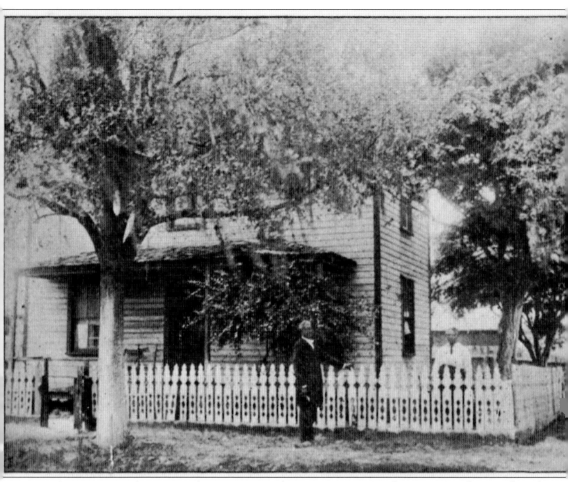

A.E. Irvin was born on a plantation in Gadson County on April 12, 1844, and was a slave for 19 years. After gaining his freedom, he learned to read and write and was active in the African Methodist Episcopal Church by 1873. Irvin and his wife are seen here in the front yard of their house in Sanford. (Courtesy of the Sanford Museum.)

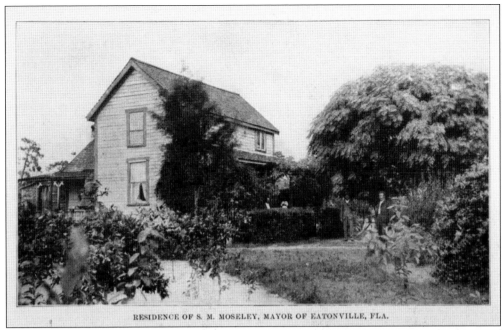

RESIDENCE OF S. M. MOSELEY, MAYOR OF EATONVILLE, FLA.

Sam Moseley was the fourth mayor of Eatonville. His home is seen here in 1907. (Courtesy of the New York Public Library.)

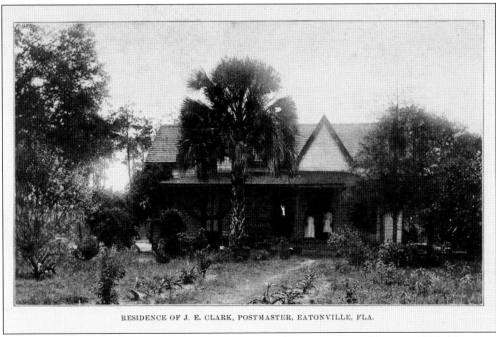

RESIDENCE OF J. E. CLARK, POSTMASTER, EATONVILLE, FLA.

Joseph E. Clark was the postmaster of Eatonville. His house is pictured here in 1907. (Courtesy of New York Public Library.)

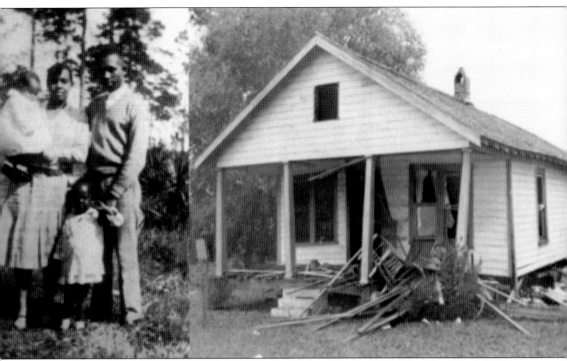

Harry T. and Harriette Moore were educators who lived in Mims. They were not only educators but activists and advocates. Pictured here are the Moore family and their home that was bombed on Christmas night in 1951. Harry died in the blast, and Harriette died days later. (Courtesy of Harry T. and Harriette V. Moore Cultural Center and Museum.)

Lawrence B. Brown was a successful businessman who owned property in Bartow. He was generous with his fortune and was a faithful member of Mt. Gilboa Missionary Baptist Church in Bartow. (Courtesy of the Historic L.B. Brown House.)

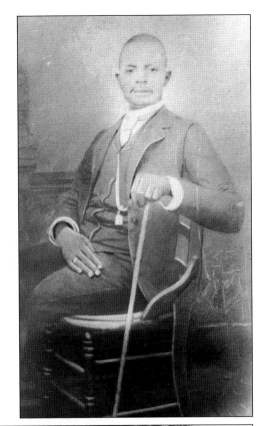

Lawrence B. Brown purchased property in the Bartow community and built 50–60 homes that he either sold or rented. This two-story Victorian mansion at 470 Second Avenue in Bartow was his home. (Courtesy of the Historic L.B. Brown House.)

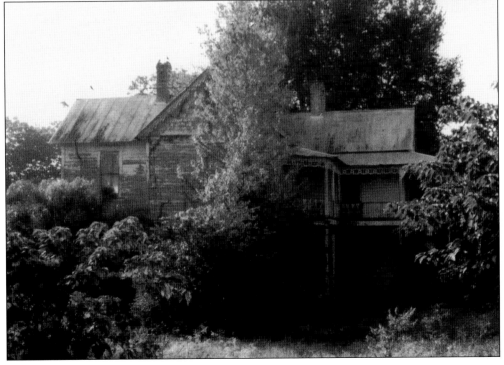

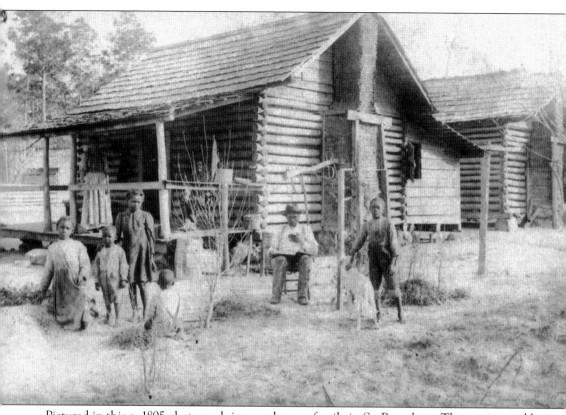

Pictured in this c. 1895 photograph is an unknown family in St. Petersburg. They were possibly some of the first settlers of the area. (Courtesy of Heritage Village Archives and Library.)

Rosa Jones was an African American woman who lived in Pinellas County. She is pictured here in front of a home in the area. (Courtesy of Heritage Village Archives and Library.)

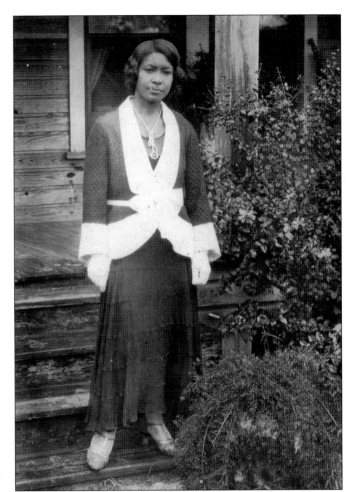

Pictured here is Rosa Jackson, as indicated on the label of the photograph, taken in 1927. The label on the back reads, "Nannie's 1927 A model Ford." (Courtesy of Heritage Village Archives and Library.)

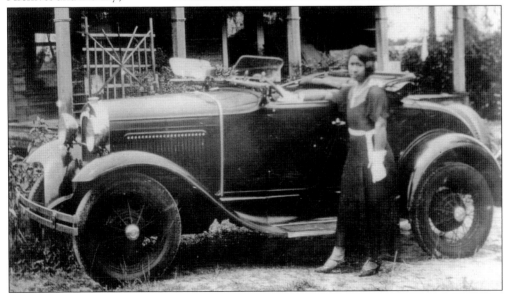

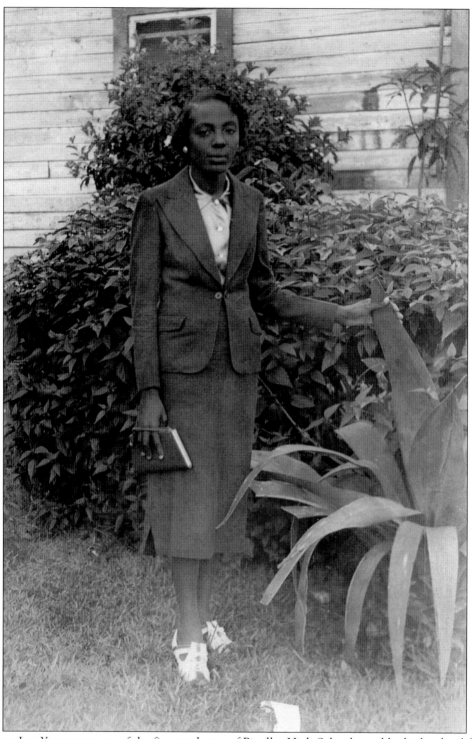

Mary Lee Young was one of the first graduates of Pinellas High School, a public high school for African Americans during segregation. She is seen here in front of a home in the area in 1934. (Courtesy of Heritage Village Archives and Library.)

Louise Ellis is pictured here in front of her home at 1300 Cedar Street in Safety Harbor. Ellis was married to George Ellis and was the sister of Ethel Williams. The home was built in 1838. (Courtesy of Bettye Burgman and Heritage Village Archives and Library.)

Lillie Brooks and her daughter are standing in front of their home at 1301 Cedar Street in Safety Harbor around 1925. (Courtesy of Bettye Burgman and Heritage Village Archives and Library.)

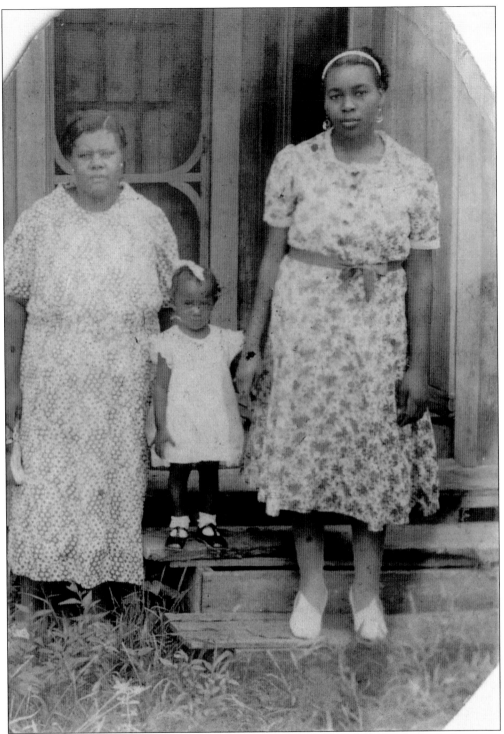

Pictured from left to right are Ethel Williams, Mary, and Ada Howell in front of a home on Pine Street in Safety Harbor around 1920. (Courtesy of Bettye Burgman and Heritage Village Archives and Library.)

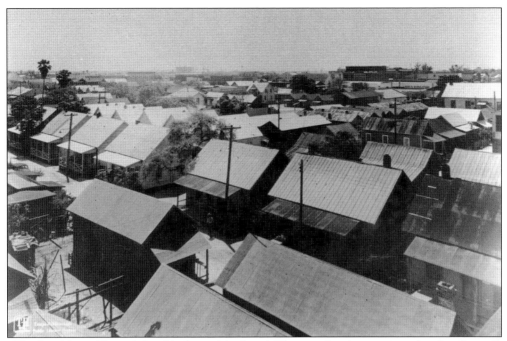

"The Scrub" was Tampa's first black neighborhood. The area first became populated with newly freed slaves after the Civil War. This view of the neighborhood was photographed on April 25, 1952. (Courtesy of Jack Moore Papers, Tampa Special Collections, University of South Florida Libraries.)

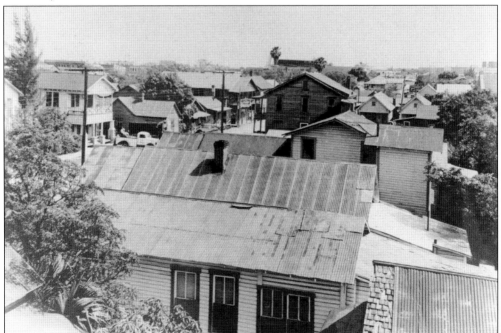

Located along Central Avenue, the Scrub was the largest black neighborhood in the 1920s. This view of the neighborhood is also from April 25, 1952. (Courtesy of Jack Moore Papers, Tampa Special Collections, University of South Florida Libraries.)

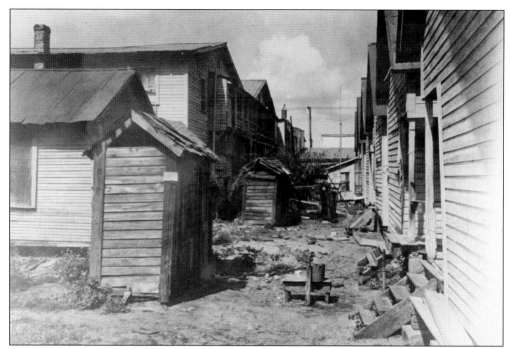

The Scrub was an overcrowded urban area for blacks during the 1950s. Although the neighborhood was one of the poorest residential locations for blacks, it was full of rich culture, with music and entertainment. Pictured here are outhouses in the backyards of the homes. (Courtesy of Jack Moore Papers, Tampa Special Collections, University of South Florida Libraries.)

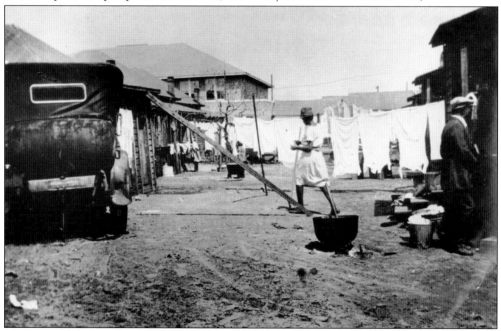

A study was conducted in 1927 called "A Study of Negro Life in Tampa." Pictured here are rental homes on India Street. (Courtesy of Jack Moore Papers, Tampa Special Collections, University of South Florida Libraries.)

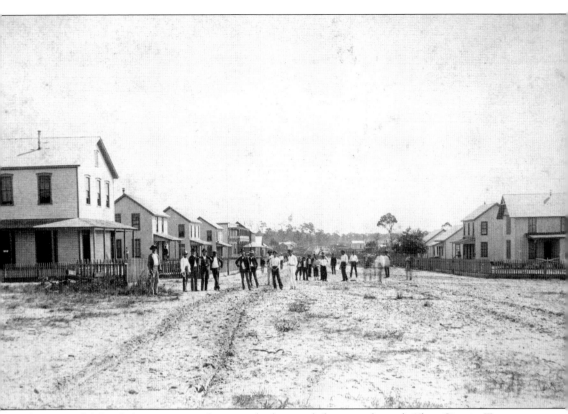

A group of Afro-Cuban men stand in a wide dirt road that ran through Ybor City in Tampa around 1885. (Courtesy of Jack Moore Papers, Tampa Special Collections, University of South Florida Libraries.)

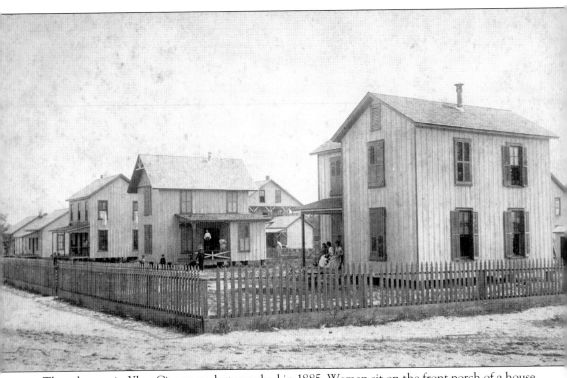

These houses in Ybor City were photographed in 1885. Women sit on the front porch of a house on the corner of a wide dirt road. (Courtesy of Jack Moore Papers, Tampa Special Collections, University of South Florida Libraries.)

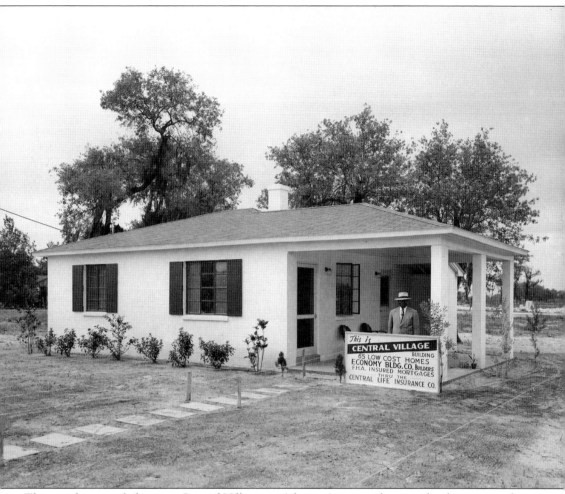

This is a close-up of a home in Central Village, an African American housing development, with Garfield Devoe Rogers, president of Central Life Insurance Company in Tampa. Rogers was a businessman and philanthropist who created opportunities for blacks to own land in Tampa. He also owned a hotel and dining room, and was part owner of a black resort near Daytona Beach. (Courtesy of Tampa-Hillsborough County Public Library System.)

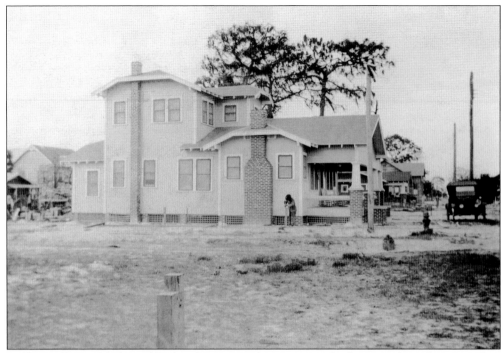

College Hill was a black neighborhood in Tampa that was researched as part of a study surrounding blacks in 1927. The homes were considered to be "a better type" of home owned by blacks in the 1920s. (Courtesy of the State Archives of Florida.)

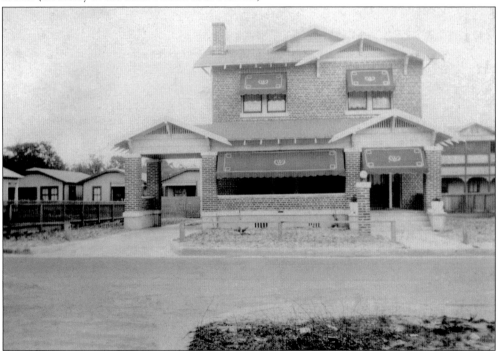

This photograph of a two-story home in College Hill was taken in March 1927. A note describes it as having electric lights and indoor plumbing. (Courtesy of the State Archives of Florida.)

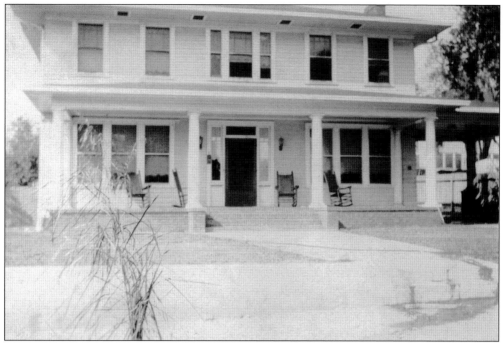

Photographed in March 1927, this house was in the West Palm Avenue neighborhood in Tampa. The population of blacks in the area was around 2,478 in the 1920s. (Courtesy of the State Archives of Florida.)

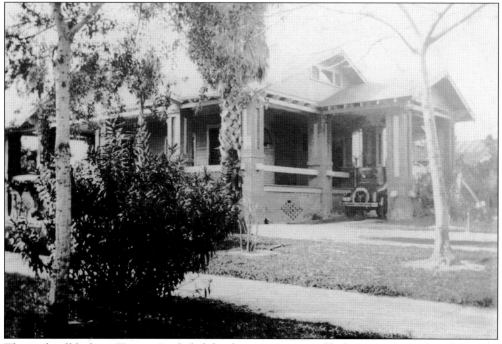

The study of blacks in Tampa concluded that homes were owned by businessmen and professionals, with some laborers and domestic servants owning as well. The house in this photograph was also in the West Palm Avenue neighborhood. (Courtesy of the State Archives of Florida.)

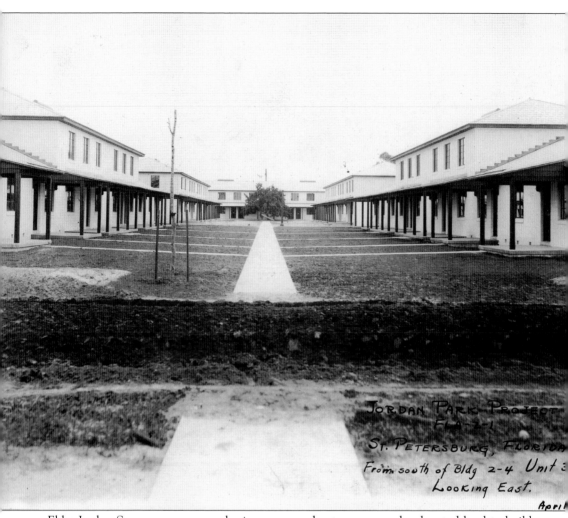

Elder Jordan Sr. was a prosperous businessman and entrepreneur who donated land to build a housing development for blacks in St. Petersburg. The first Jordan Park residential units were constructed between 1939 and 1941. (Courtesy of Jordan Park Collection, St. Petersburg Special Collections, University of South Florida Libraries.)

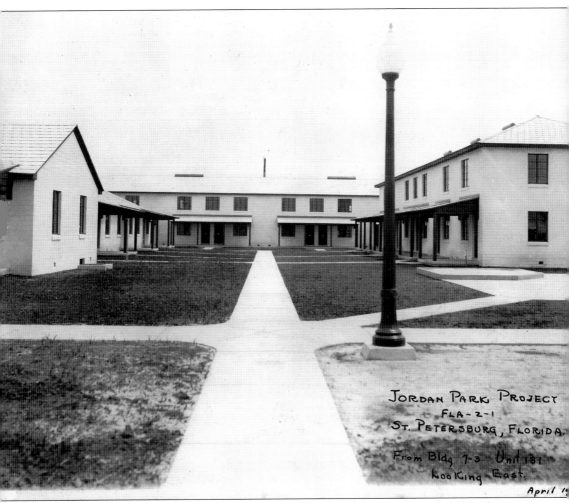

Jordan Park was built in the hopes of replacing structures in Peppertown and the Gas Plant district. Pictured here is an April 1940 photograph of Jordan Park looking east. (Courtesy of Jordan Park Collection, St. Petersburg Special Collections, University of South Florida Libraries.)

This photograph shows a Jordan Park home after construction was finished, when residents were occupying the units. The first phase of Jordan Park included 242 units. After some challenges, the second phase was completed, housing a total of 1,800 blacks. (Courtesy of Jordan Park Collection, St. Petersburg Special Collections, University of South Florida Libraries.)

Six

PALM BEACH COUNTY

The Palm Beach area was first settled by blacks in the late 1890s. They worked as laborers and lived in a community known as "the Styx." The oceanfront community was full of former slaves and people from the Caribbean islands who arrived in the area seeking work. About 2,000 blacks lived in the community, which was never fully developed. Around 1,912 blacks moved out of the area; many historians have called it a "forcible move" because of the living conditions of the neighborhood. The new location where they settled is now known as the Northwest neighborhood of Palm Beach. By the early 1920s, black laborers were living in shotgun homes with their families. As time marched on, other communities developed, including the Pleasant City neighborhood, and the Riviera Beach area became another community that was created due to a large number of blacks in the region. Delray Beach, Belle Glade, and Boca Raton were all neighborhoods that eventually were created and populated with blacks.

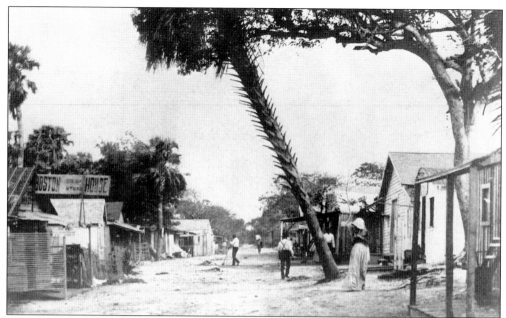

A settlement of black laborers and families descended upon an area known as the Styx in Palm Beach. This photograph shows a street scene in the Styx in 1895. (Courtesy of the State Archives of Florida.)

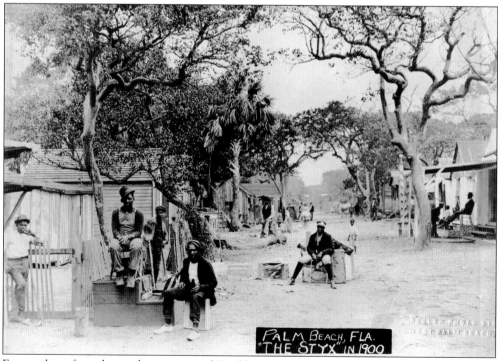

Former slaves from the northern states and Caribbean people settled in the Styx. The area included shacks and some structures that were more stable, including a church. The people settled in the area while they were constructing a hotel in Palm Beach. (Photograph by Resler Photo Studio, courtesy of the State Archives of Florida.)

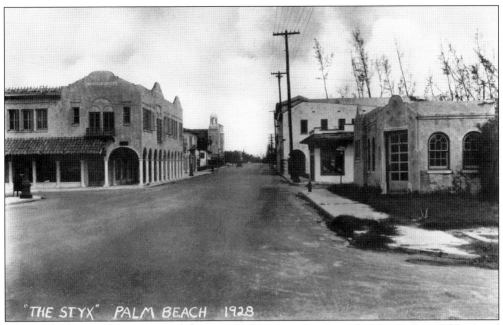

In 1894, the blacks who settled in the Styx were forced to relocate to the Northwest neighborhood of Palm Beach. This photograph was taken in 1928 and shows businesses and residences in the community. (Photograph by Resler Photo Studio, courtesy of the State Archives of Florida.)

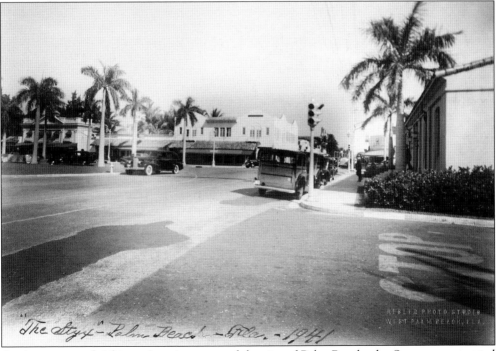

As the segregated African American part of the city of Palm Beach, the Styx was converted into a commercial and residential area from 1929 to 1960. Palm trees lined the streets, as seen in this photograph from 1941. (Photograph by Resler Photo Studio, courtesy of the State Archives of Florida.)

Several shotgun homes were built in the Northwest neighborhood of West Palm Beach during the boom era. The house in this photograph, as well as others, were instrumental in the development of the community. (Courtesy of Florida Master Site File, Florida Division of Historical Resources.)

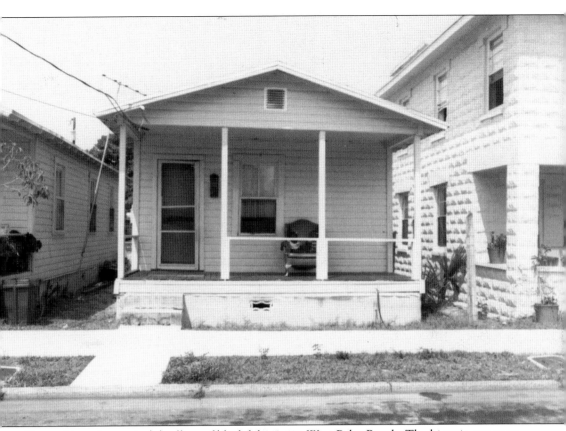

Pictured here is a typical dwelling of black laborers in West Palm Beach. The historic structure is on a northeast corner of Sixth Street. (Courtesy of Florida Master Site File, Florida Division of Historical Resources.)

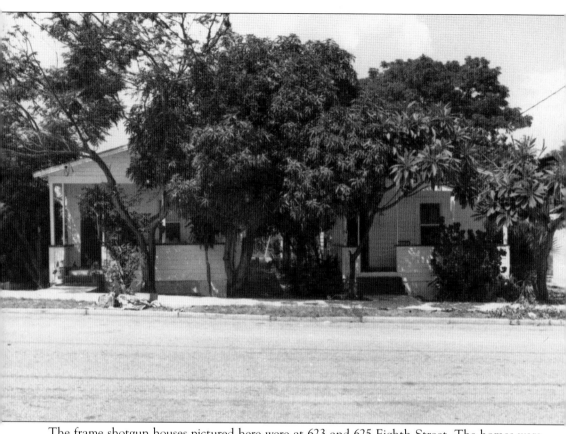

The frame shotgun houses pictured here were at 623 and 625 Eighth Street. The homes were built around 1923 as rental property for blacks in the area. (Courtesy of Florida Master Site File, Florida Division of Historical Resources.)

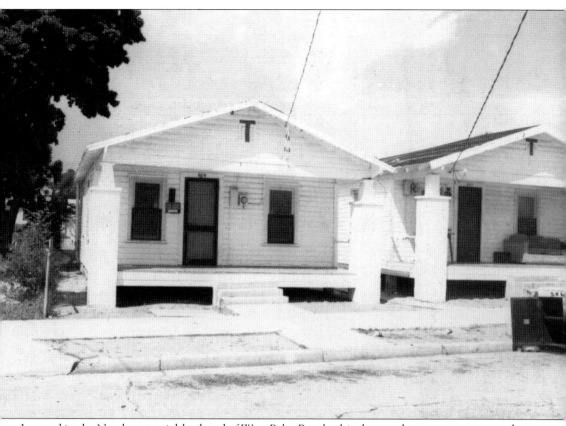

Located in the Northwest neighborhood of West Palm Beach, this shotgun house was constructed in the early 20th century. It holds historical significance due to its construction during the Depression. (Courtesy of Florida Master Site File, Florida Division of Historical Resources.)

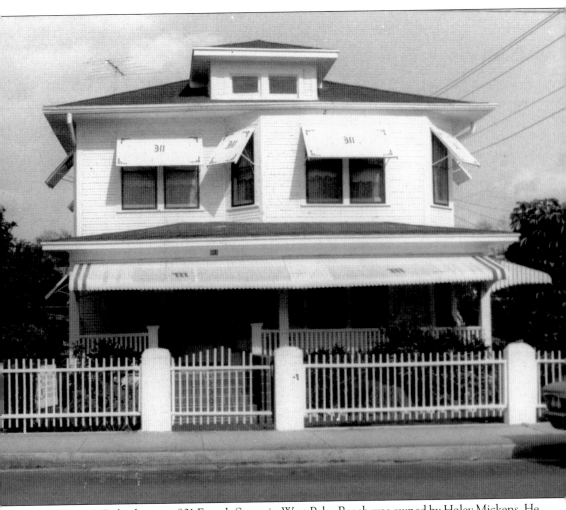

Built in 1917, this home at 801 Fourth Street in West Palm Beach was owned by Haley Mickens. He and his wife, Alice, were pillars of the community in Northwest who contributed to its success. The house was a place for prominent scholars and leaders to visit as guests when in the area, including Ralph Bunche. (Courtesy of Florida Master Site File, Florida Division of Historical Resources.)

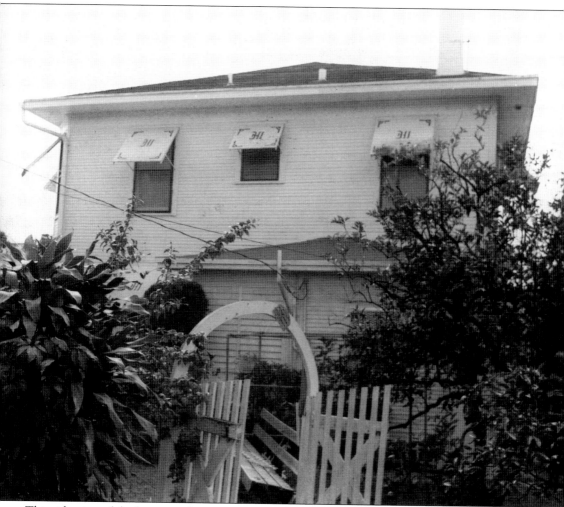

This side view of the home on the previous page shows awnings with an "M" for its owners, the Mickens family. Alice Moore, a foster daughter of the family, lived here for 80 years. (Courtesy of Florida Master Site File, Florida Division of Historical Resources.)

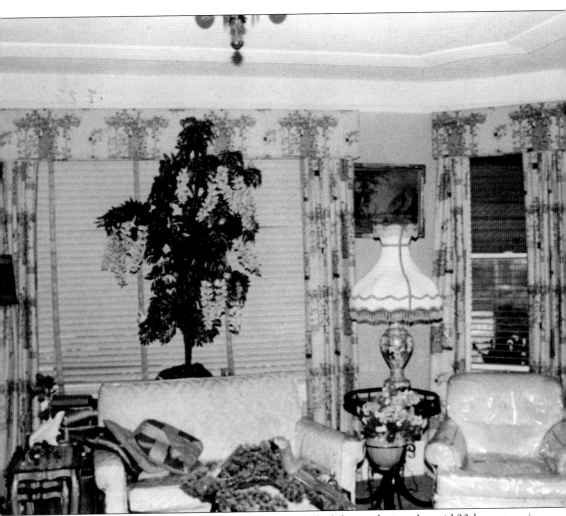

The interior of the Mickens home shows a typical black home during the mid-20th century in West Palm Beach. It is the oldest residence in the community that has been owned by African Americans and is listed in the National Register of Historic Places. (Courtesy of Florida Master Site File, Florida Division of Historical Resources.)

Born in 1887, Solomon D. Spady was an educator, scientist, administrator, and one of the most influential African Americans in Delray Beach. In 1922, Spady arrived in Florida at the recommendation of George Washington Carver, an African American scientist and inventor. (Courtesy of the Spady Cultural Heritage Museum.)

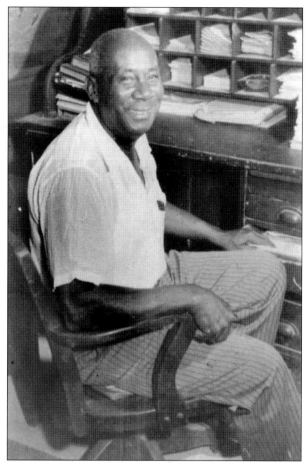

Construction began on the Spady home in 1925. It was built as a two-story single-family residence in a rectangular shape, in stucco with a stone foundation. It was considered a unique home and a step above other homes in the area. The Spady home also was the first in Delray Beach to have indoor plumbing, electricity, and a telephone. (Courtesy of the Spady Cultural Heritage Museum.)

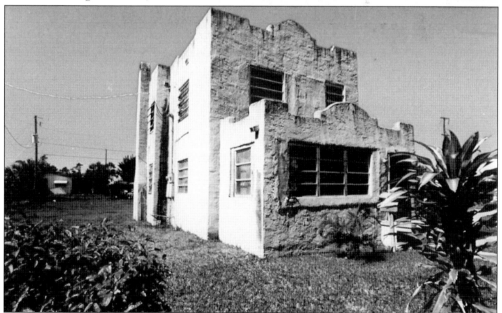

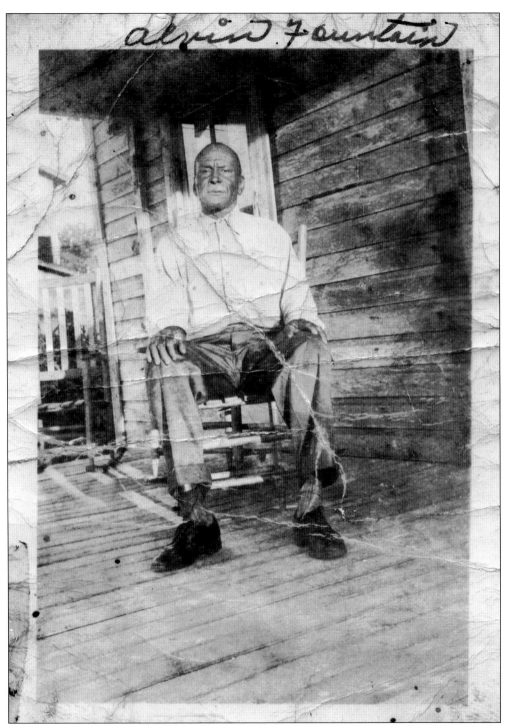

Alvin and Gladys Fountain came from Georgia to settle in the Pearl City neighborhood of Boca Raton in 1924. They built a small wooden house at 156 Pearl Street in 1929, raised seven children, and lived out the rest of their lives in the same home. Alvin is pictured here on the front porch. (Courtesy of the Boca Raton Historical Society & Museum.)

Seven

MIAMI

Black history in Miami dates back to the 1690s with the arrival of black pirates. From the time of the first arrival of blacks through today, many people of different cultural backgrounds have settled here. One of the largest groups were Bahamians who arrived to help with the construction of hotels, buildings, and other structures in the area. The building of the railroads also sent a large population of blacks throughout Florida and to Miami. The Overtown community of Miami was established in 1896 and was originally called "Colored Town." The tight-knit community included blacks from different income levels, all living together within the neighborhood. In the 1900s, Overtown was thriving with grocery stores, churches, schools, and even a drugstore. Black residents of neighboring communities of Coconut Grove and Little Haiti would travel to Overtown to enjoy its amenities. Bahamian immigrants settled in the neighborhoods of Coconut Grove and Coral Gables. The Bahamian men who arrived in Coral Gables were skillful in building with the coral rock that can be found in many structures in the area. One of the first residents of Coconut Grove was Mariah Brown, whose home was built in 1892. Brown was employed as a domestic worker for the wealthy Peacock family. D.A. Dorsey and E.W.F. Stirrup were two millionaires who were residents of Miami. Dorsey and Stirrup built their own homes and created avenues for other blacks in the community to own property and enjoy life. Dorsey was the owner of an island that is known today as Fisher Island. He purchased the island as a place for blacks to enjoy the beach. This chapter gives a glimpse into the lives of blacks in Overtown, Coconut Grove, and Coral Gables.

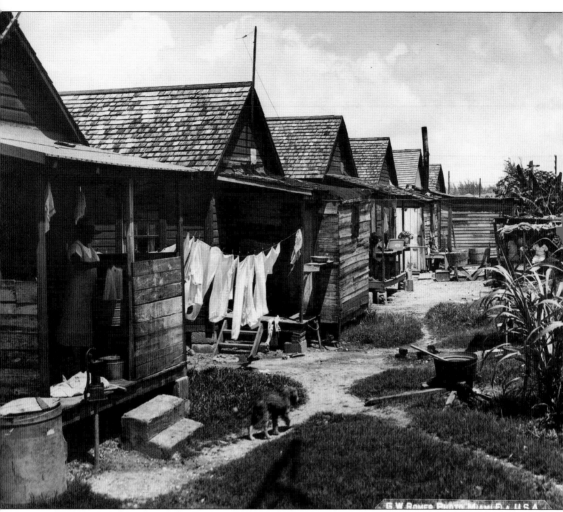

Some of the housing in Overtown was inadequate, the roads were not paved, and it was overpopulated. Despite these conditions, people took pride in what they owned. Pictured here is a woman doing her laundry by hand. (Photograph by G.W. Romer, courtesy of Special Collections, University of Miami Libraries.)

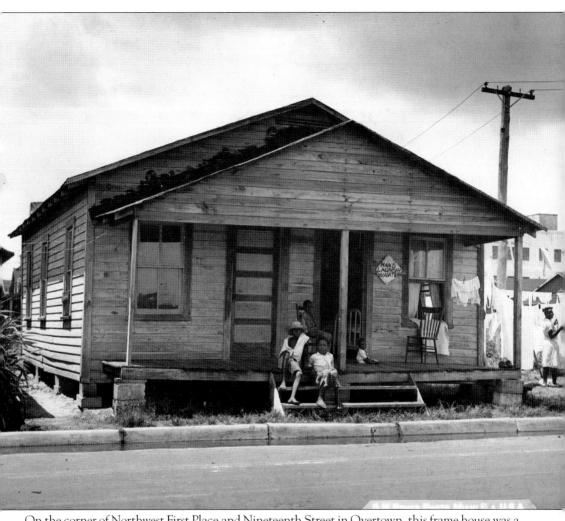

On the corner of Northwest First Place and Nineteenth Street in Overtown, this frame house was a typical residence in the neighborhood. Four children sit on the porch while a young woman hangs laundry. A sign on the front of the home appears to be advertising for laundry help. (Photograph by G.W. Romer, courtesy of Special Collections, University of Miami Libraries.)

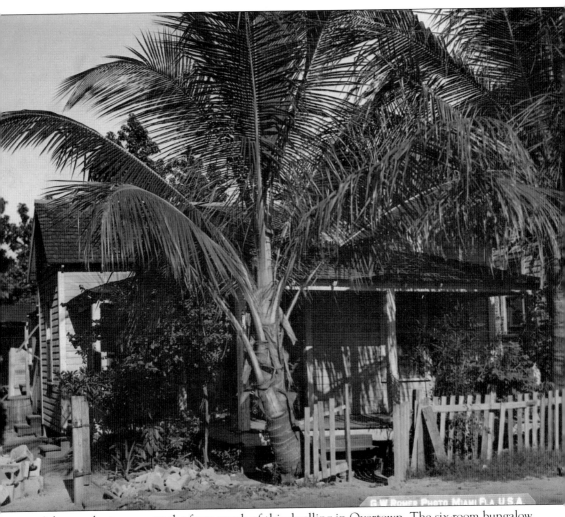

A large palm tree covers the front porch of this dwelling in Overtown. The six-room bungalow was at 1667 Northwest Fifth Avenue. (Photograph by G.W. Romer, courtesy of Special Collections, University of Miami Libraries.)

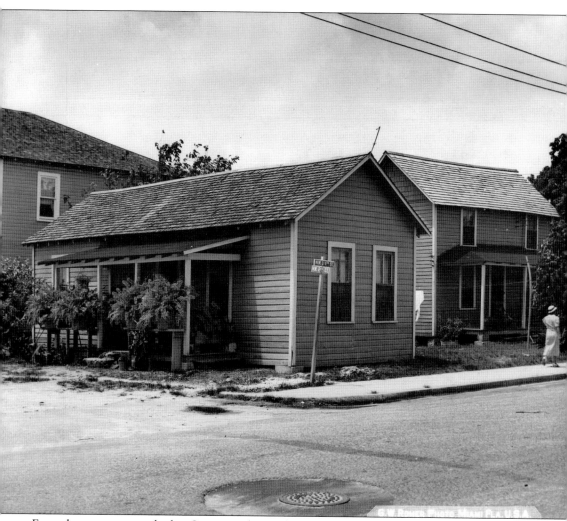

Frame houses were standard in Overtown during the 1930s and 1940s. Pictured here is a four-room house at the corner of Northwest Second Court and Northwest Tenth Street. (Photograph by G.W. Romer, courtesy of Special Collections, University of Miami Libraries.)

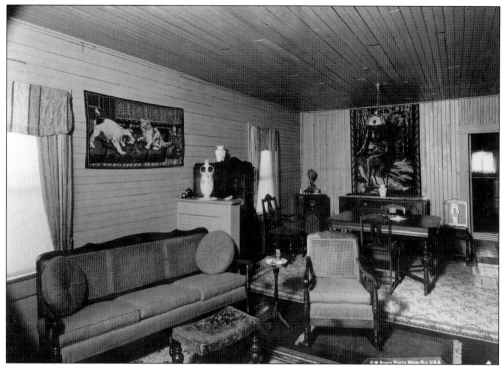

Residents of Overtown were meticulous in decorating and caring for their homes. The interiors demonstrated the character of the owner. The interior of this home at 355 Northwest Ninth Street was filled with wooden furniture. (Photograph by G.W. Romer, courtesy of Special Collections, University of Miami Libraries.)

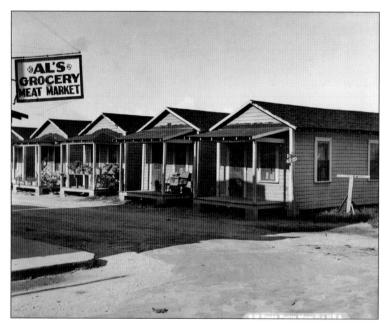

The homes pictured here are well-kept, with potted plants and rocking chairs on the porches. Located in the Northwest Second Court, the residences are three-room frame structures across the street from the local market. (Photograph by G.W. Romer, courtesy of Special Collections, University of Miami Libraries.)

The MacFarlane neighborhood in Coral Gables was settled by Bahamian laborers who came here to work. Chandler and Ada B. Cason owned this home at 121 Florida Avenue. Chandler built the home himself with the exception of the plumbing. It was completed in 1936. (Courtesy of Leona Cooper Baker.)

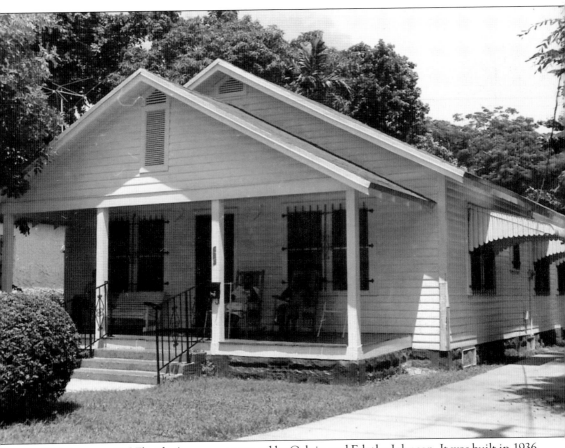

This home at 125 Florida Avenue was owned by Calvin and Edythe Johnson. It was built in 1936 with a spacious porch, which was a meeting place for neighbors. After dinner, the adults would gather and share stories. (Courtesy of Leona Cooper Baker.)

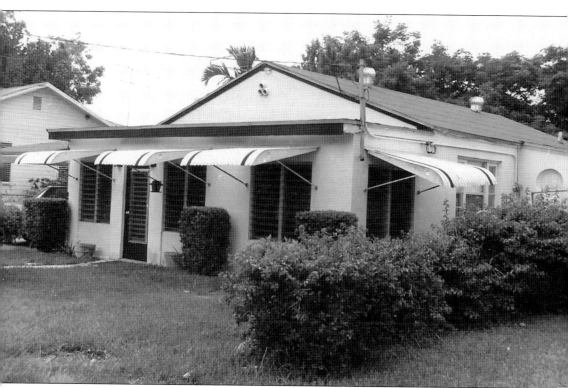

Built in the early 1930s, this home at 126 Florida Avenue was built and owned by Leonard Hopkins, a Bahamian. Hopkins not only built his own home but also several shotgun houses in Coral Gables. (Courtesy of Leona Cooper Baker.)

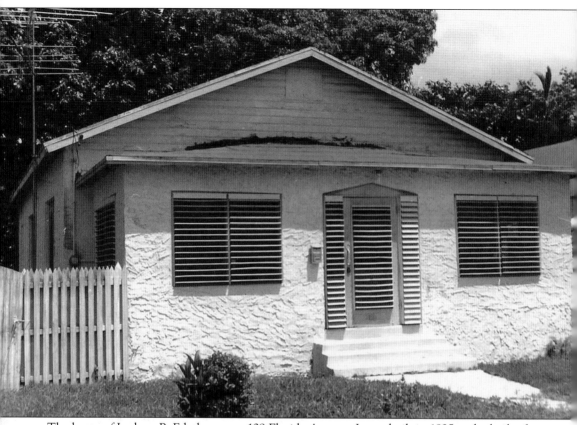

The home of Lerlean B. Edythe was at 129 Florida Avenue. It was built in 1925 and rebuilt after the 1926 hurricane. Today, it is still owned by Edythe's grandchildren. (Courtesy of Leona Cooper Baker.)

Bernice and Octavious Gibson of Coral Gables lived at 134 Florida Avenue. Their daughter Beverly is still living in the home. (Courtesy of Leona Cooper Baker.)

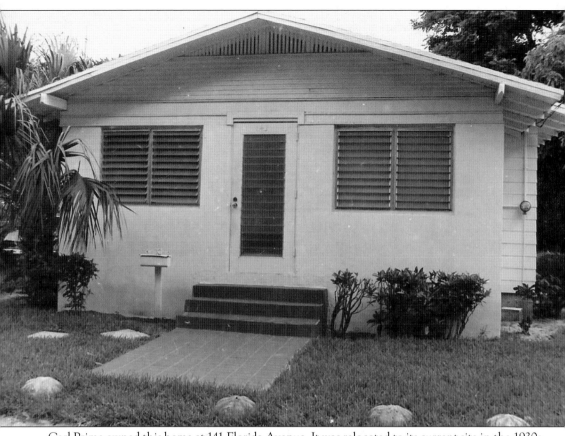

Carl Prime owned this home at 141 Florida Avenue. It was relocated to its current site in the 1930s and is still occupied by Carl's widow, Edwina. (Courtesy of Leona Cooper Baker.)

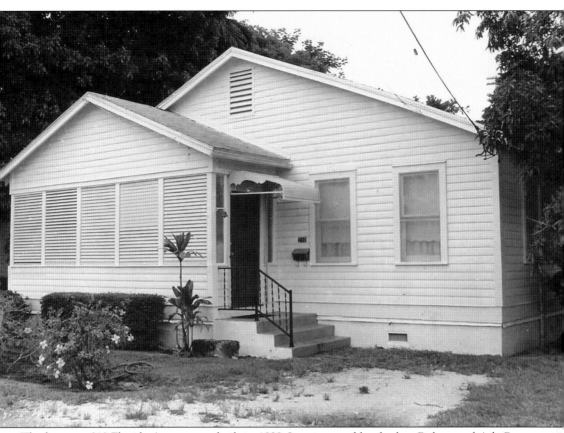

The home at 210 Florida Avenue was built in 1939. It was owned by the late Robert and Ada B. Dunn, who also owned a drugstore on Grand Avenue called the Dew Drop Inn. (Courtesy of Leona Cooper Baker.)

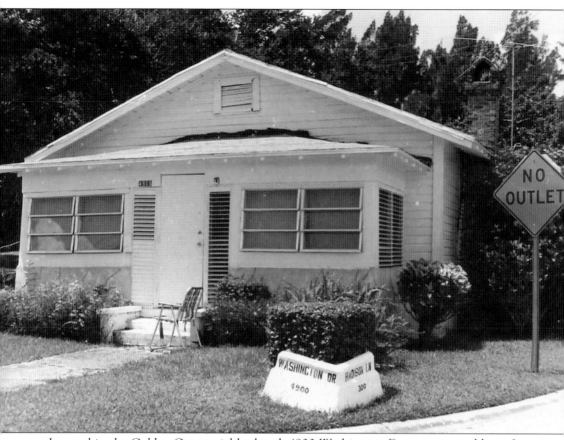

Located in the Golden Gates neighborhood, 4900 Washington Drive is pictured here. It was owned by Merries Moore Johnson and built in 1925. (Courtesy of Leona Cooper Baker.)

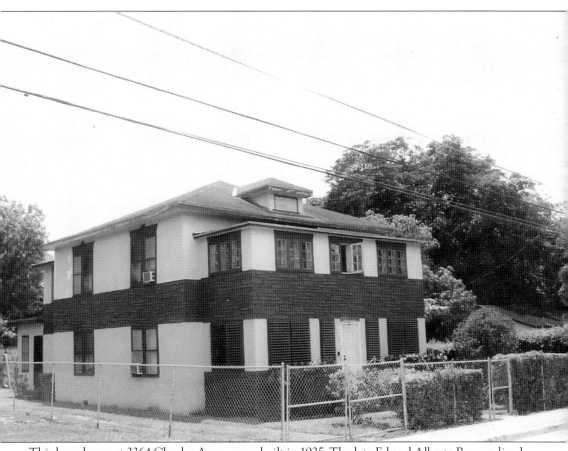

This large home at 3364 Charles Avenue was built in 1925. The late Ed and Alberta Bunyan lived here with their daughter, Mary, who was born in the house and still lives there today. (Courtesy of Leona Cooper Baker.)

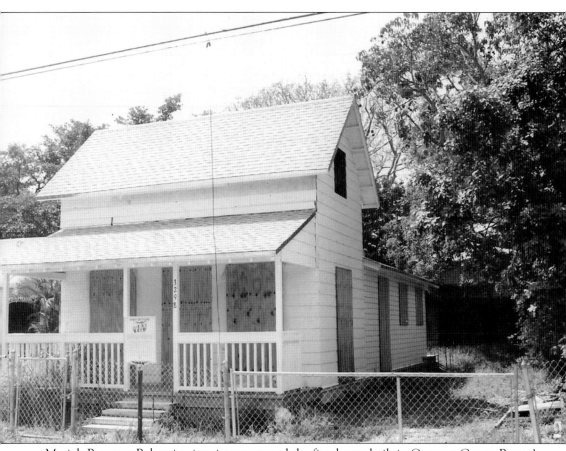

Mariah Brown, a Bahamian immigrant, owned the first house built in Coconut Grove. Brown's home was built in 1892 within walking distance of the Peacock Inn. (Courtesy of Leona Cooper Baker.)

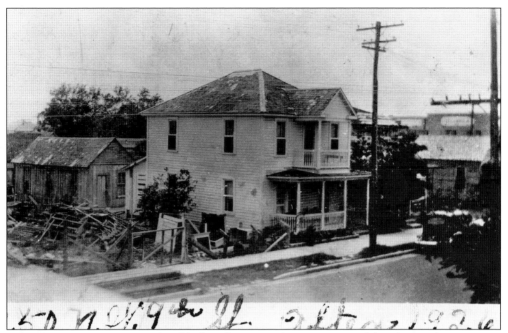

Dana A. Dorey was Miami's first black millionaire. He was a successful real estate businessman and philanthropist. Dorsey's home on Northwest Ninth Street was built in 1913. It is pictured here after the 1926 hurricane. (Courtesy of Black Archives History and Research Foundation and Florida Master Site File, Florida Division of Historical Resources.)

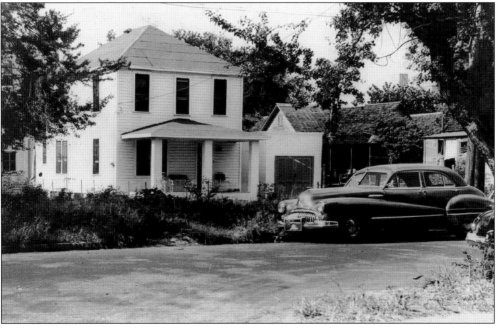

Pictured here is the Dorsey residence in 1930. The frame vernacular structure was built for his wife, Rebecca Livingston, and it has been documented that Dorsey designed and built the home. (Courtesy of Black Archives History and Research Foundation and Florida Master Site File, Florida Division of Historical Resources.)

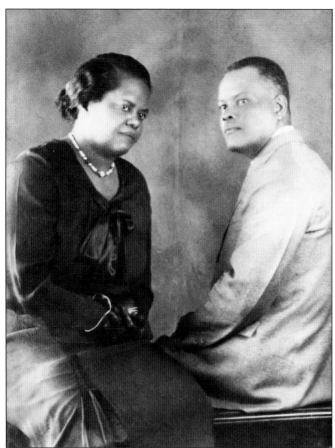

Dr. William Chapman was one of the first black physicians in the Miami area and is known for his work with infectious diseases. He and his wife, Mary Louise, are pictured here. (Courtesy of State Archives of Florida.)

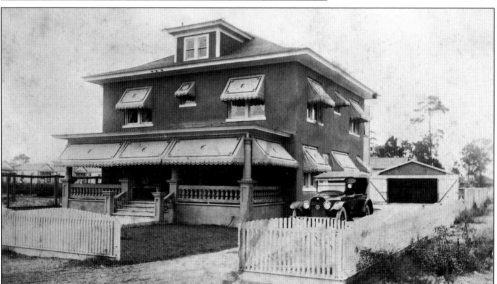

This two-story home was owned by Chapman and was both his office and residence. Located in Overtown, it is currently on the grounds of Booker T. Washington High School. (Courtesy of State Archives of Florida.)

Eight

TODAY'S AFRICAN AMERICAN HISTORIC HOMES

Several homes that were built in the late 1890s and the early 1900s have been preserved and hold historical significance in communities throughout Florida. The famous poet and author Zora Neale Hurston's last residence before she died still stands today in Fort Pierce. Doctors, businessmen, educators, and activists' homes have been designated as historic properties. The private residences of blacks who affected the history of Florida have become cultural institutions and museums. Florida has a strong community of historians, preservationists, and community members who value the history of these homes and their owners. This chapter highlights some of the homes that are presently standing in neighborhoods throughout the state.

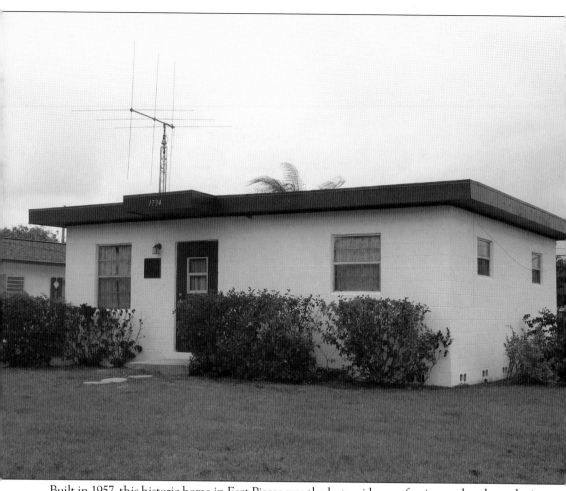

Built in 1957, this historic home in Fort Pierce was the last residence of writer and anthropologist Zora Neale Hurston. It is a one-story structure that is simple and not distinctive in its design. The home is in a residential area of Fort Pierce and is not open to the public. (Courtesy of Florida Master Site File, Florida Division of Historical Resources.)

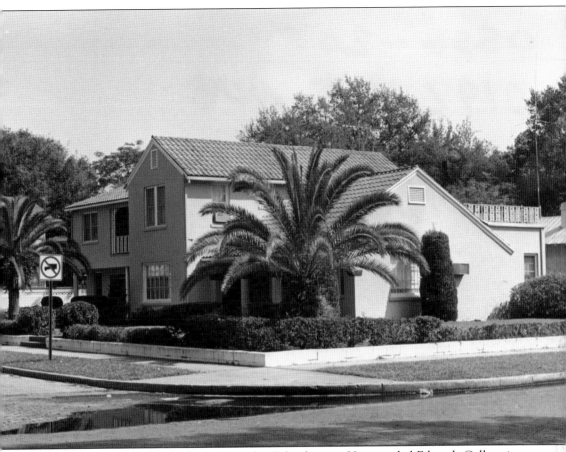

Dr. I.C. Hankins was a black physician in the Orlando area. He attended Edwards College in Jacksonville and Howard University Medical School in Washington, DC. Hankins started practicing medicine in Orlando in 1926 and was instrumental in motivating blacks to own their own property. His home was built in 1935. (Courtesy of Florida Master Site File, Florida Division of Historical Resources.)

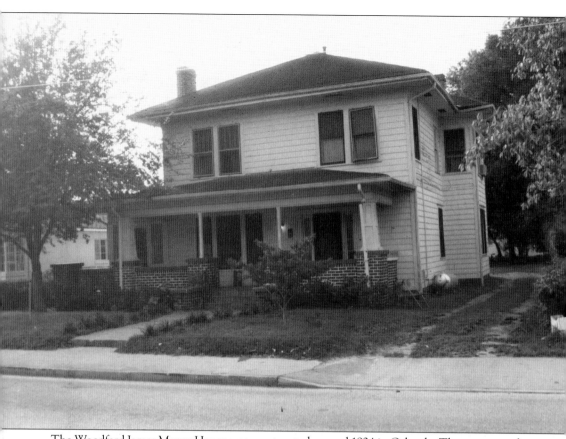

The Woodford James Maxey House was constructed around 1924 in Orlando. The two-story, frame vernacular dwelling reflects the progress of blacks in the area during unfair and discriminatory times. (Courtesy of Florida Master Site File, Florida Division of Historical Resources.)

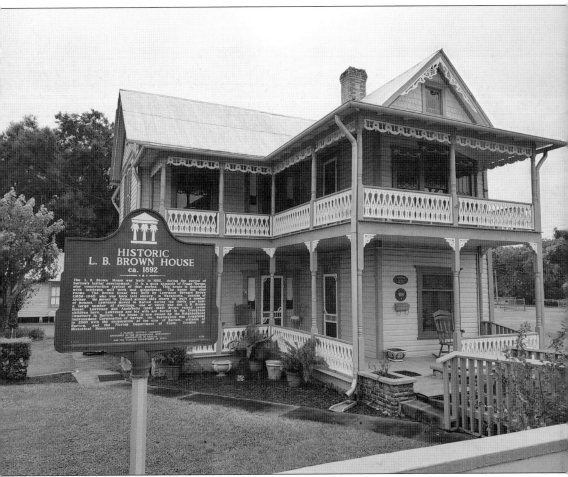

The L.B. Brown House is pictured as it stands today in Bartow. The residence was renovated in the 1990s and is a house museum that preserves the legacy of the success of former slaves in the Bartow area. (Courtesy of the L.B. Brown House.)

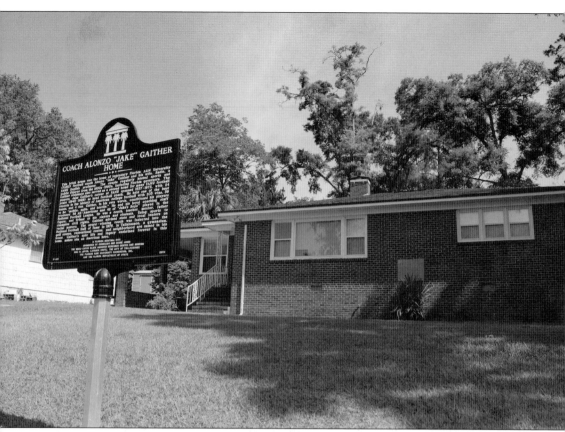

Jake Gaither was a legendary football coach at Florida Agricultural & Mechanical University from 1945 to 1969. During his tenure, the team were black national college champions six times. His home has been transformed into a museum. (Courtesy of Florida Master Site File, Florida Division of Historical Resources.)

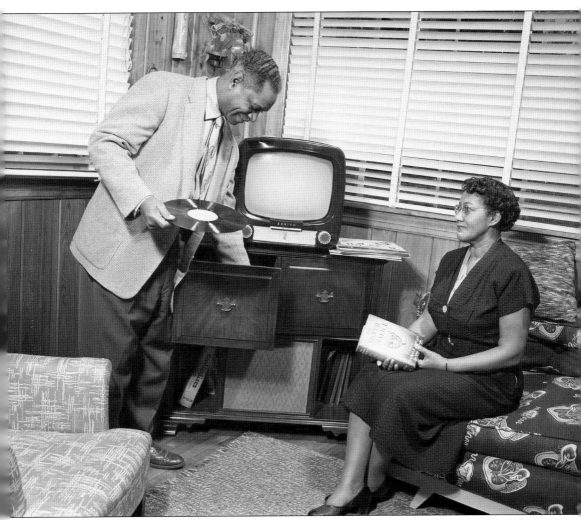

Jake and Sadie Gaither are pictured here in their home, which they moved into in 1954. The Gaithers' residence was also a place for football players to call home while away from college. (Courtesy of Florida State Archives.)

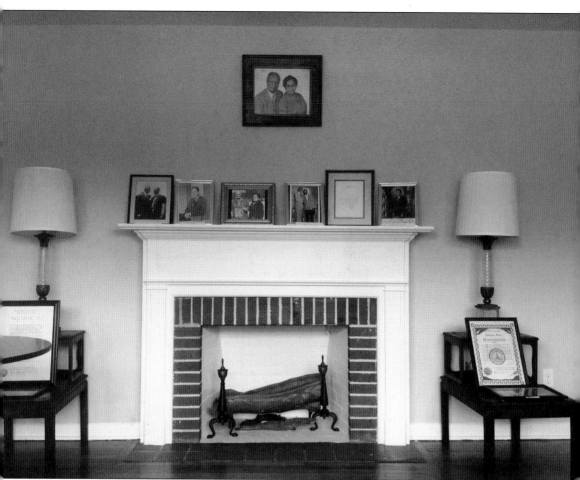

Today, the Gaither residence is a house museum that highlights the legacy of his life and accomplishments. It has been renovated and is listed in the National Register of Historic Places. Visitors can view photographs of Gaither and his family throughout the home. (Courtesy of Florida Master Site File, Florida Division of Historical Resources.)

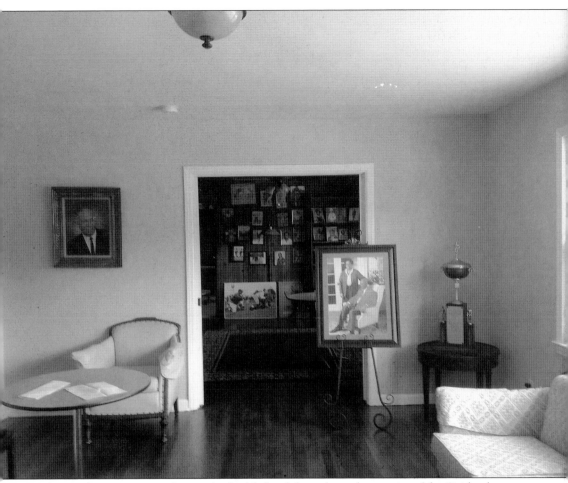

Trophies and newspaper articles are also highlighted throughout the interior of the Gaither home. Gaither had a collection of photographs in the home, including former football players. (Courtesy of Florida Master Site File, Florida Division of Historical Resources.)

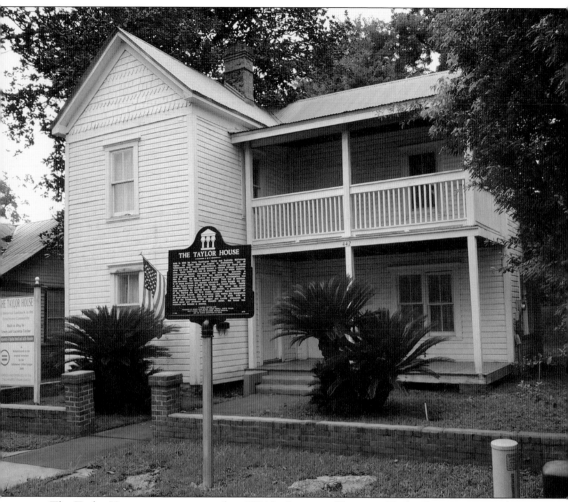

The Taylor House was constructed in 1894 by Lewis and Lucretia Taylor. Lewis was an educator, businessman, and local leader in Tallahassee. Lucretia, who was born a slave, was a master cook and seamstress. The residence is in the Frenchtown historic neighborhood of Tallahassee. Today, it is a house museum owned by the Tallahassee Urban League. (Courtesy of Florida Master Site File, Florida Division of Historical Resources.)

One of the first black employees of the Florida Supreme Court, Joe Butler, is pictured here with his wife, Annie. Butler served in different positions from 1928 until 1972, when he retired. (Courtesy of Florida State Archives.)

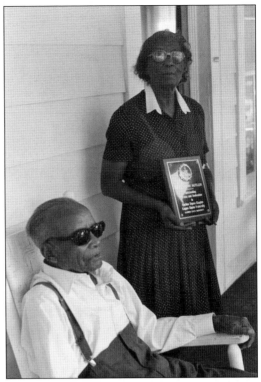

Joe Butler's residence in Tallahassee is pictured here in 1987. (Courtesy of Florida State Archives.)

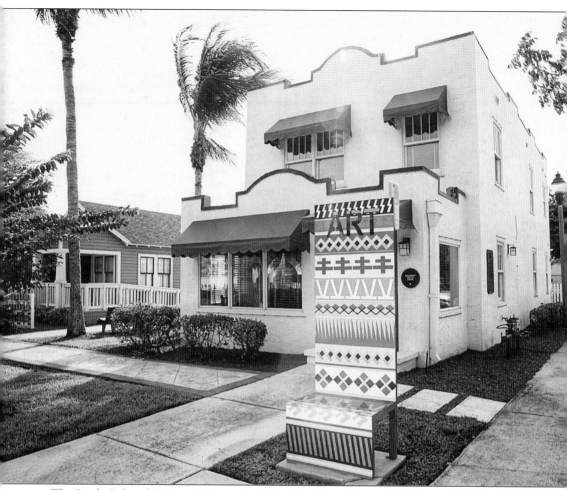

The Spady Cultural Heritage Museum in Delray Beach was formerly the home of the Spady family. It is dedicated to the African American history and culture of Palm Beach County. (Courtesy of the Spady Culture Heritage Museum.)

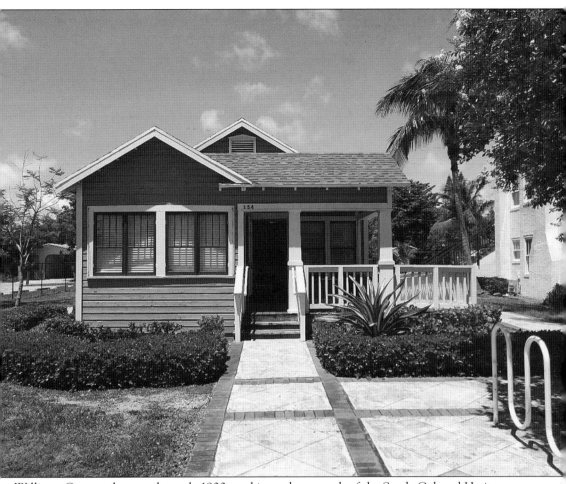

Williams Cottage dates to the early 1900s and is on the grounds of the Spady Cultural Heritage Museum. The historic cottage was the site of the first African American settlement in the community. (Courtesy of Spady Cultural Heritage Museum.)

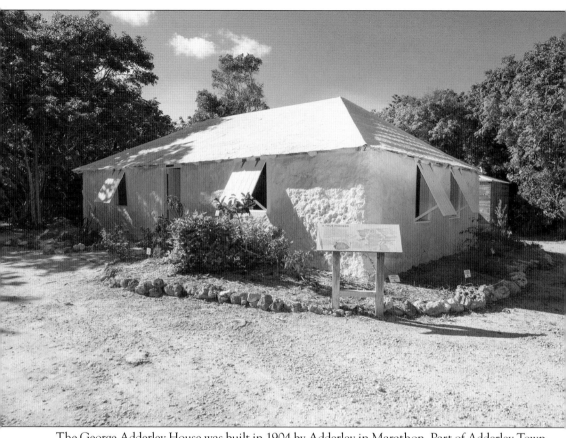

The George Adderley House was built in 1904 by Adderley in Marathon. Part of Adderley Town, it is the only full-standing tabby house in Florida and the oldest house in the Florida Keys outside of Key West. (Courtesy of the Crane Point Museum & Nature Center.)

AFTERWORD

Florida's Historic African American Homes exposes the rare gems that are hidden within the state. Some are museums and cultural institutions that interpret, educate, and exhibit the history of African Americans. The history of these house museums and cultural institutions, depicted here in photographs, offers a peek into the lives of the remarkable African Americans of Florida. Serving as a guide to a full understanding of the history, lives, and accomplishments of black Floridians, this book shines a spotlight on these residences and provides understanding of how African American millionaires, educators, and humanitarians contributed to not only African American history, but also American history.

Vedet Coleman-Robinson
Executive Director
Association of African American Museums

DISCOVER THOUSANDS OF LOCAL HISTORY BOOKS FEATURING MILLIONS OF VINTAGE IMAGES

Arcadia Publishing, the leading local history publisher in the United States, is committed to making history accessible and meaningful through publishing books that celebrate and preserve the heritage of America's people and places.

Find more books like this at
www.arcadiapublishing.com

Search for your hometown history, your old stomping grounds, and even your favorite sports team.

MADE IN THE USA